THE LAND HAS MEMORY

*Black Hill
Regional Park,
Maryland.*

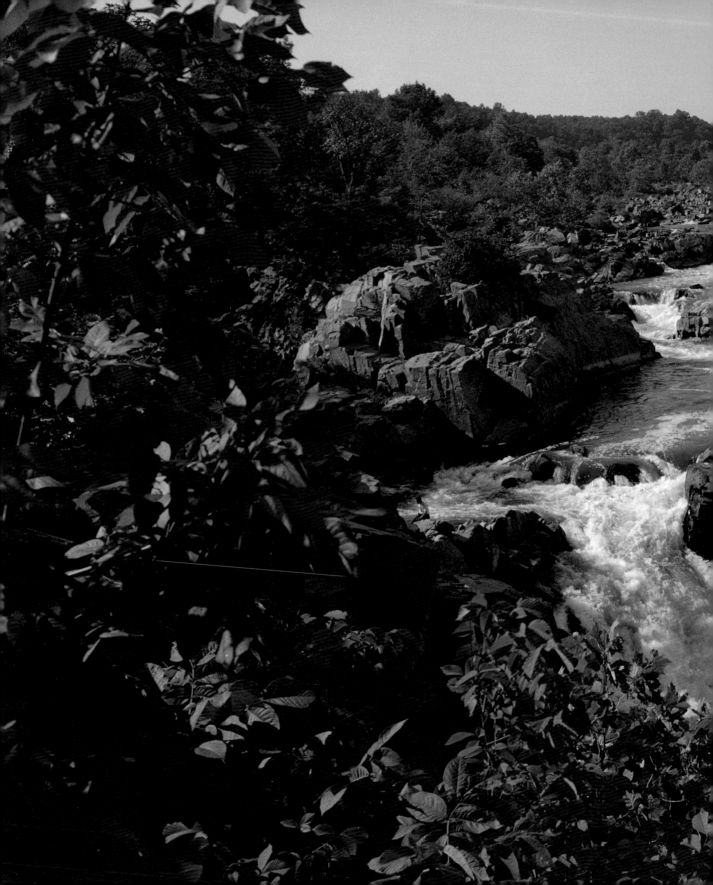

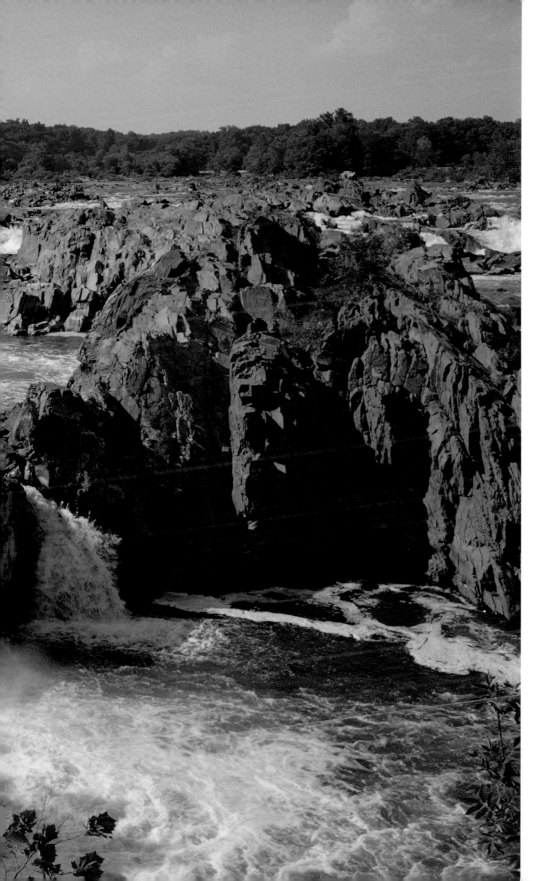

Great Falls of the Potomac, Virginia/ Maryland border.

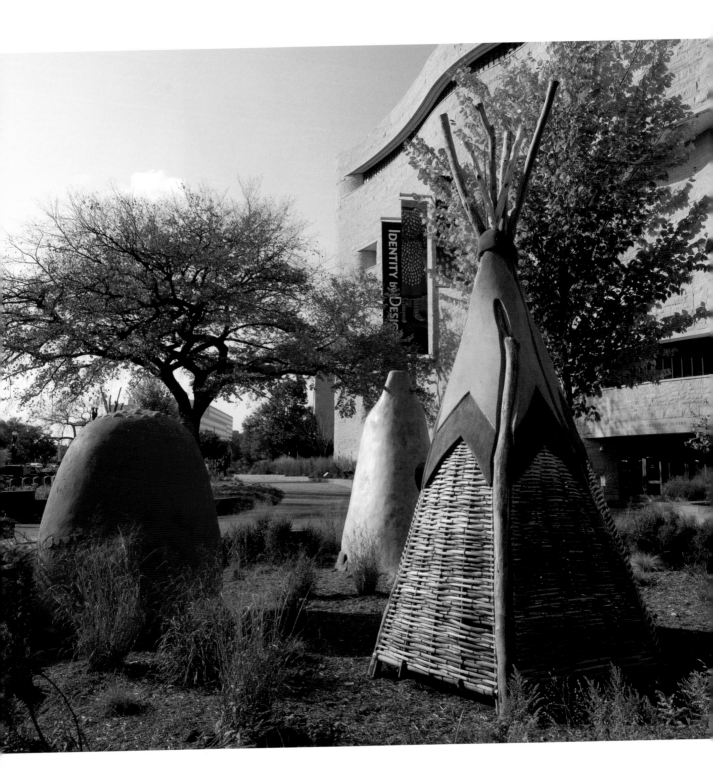

THE LAND
HAS MEMORY

INDIGENOUS KNOWLEDGE,
NATIVE LANDSCAPES, *and the*
NATIONAL MUSEUM OF THE
AMERICAN INDIAN

Edited by
DUANE BLUE SPRUCE
and
TANYA THRASHER

Published in association with the
National Museum of the American Indian,
Smithsonian Institution, by The University
of North Carolina Press, Chapel Hill

The National Museum of the American Indian, Smithsonian Institution, is dedicated to working in collaboration with the indigenous peoples of the Americas to foster and protect Native cultures throughout the Western Hemisphere. The museum's publishing program seeks to augment awareness of Native American beliefs and lifeways and to educate the public about the history and significance of Native cultures. For more information about the Smithsonian's National Museum of the American Indian, visit the NMAI website at www.AmericanIndian.si.edu.

NATIONAL MUSEUM *of the* AMERICAN INDIAN
Project Director:
Terence Winch,
Head of Publications
Editors:
Duane Blue Spruce
(Laguna/San Juan Pueblo)
and Tanya Thrasher
(Cherokee Nation of Oklahoma)

Smithsonian
National Museum of the American Indian

University of North Carolina Press books may be purchased at a discount for educational, business, or sales promotional use. For information, please visit www.uncpress.unc.edu or write to UNC Press, attention: Sales Department, 116 South Boundary Street, Chapel Hill, NC 27514-3808.

Designed and typeset by Kimberly Bryant
Set in Arno Pro and Othello

Title page illustration: *Always Becoming* sculptures in NMAI's meadow, 2007.

Halftitle page illustrations: Details of *Po Khwee* (Moon Woman) (p. i) and *Ping Tse Deh* (Mountain Bird) (p. xvii) sculptures.

The paper in this book meets the guidelines for permanence and durability of the Committee on Production Guidelines for Book Longevity of the Council on Library Resources.

The University of North Carolina Press has been a member of the Green Press Initiative since 1993.

FIRST EDITION

LIBRARY OF CONGRESS CATALOGING-IN-PUBLICATION DATA
The land has memory : indigenous knowledge, native landscapes, and the National Museum of the American Indian / edited by Duane Blue Spruce and Tanya Thrasher. — 1st ed.
 p. cm.
Includes bibliographical references and index.
ISBN 978-0-8078-3264-6 (cloth : alk. paper) — ISBN 978-0-8078-5936-0 (pbk. : alk. paper)
1. Indians of North America — Ethnobotany — Washington (D.C.) — Pictorial works.
2. National Museum of the American Indian (U.S.) — Buildings — Pictorial works.
3. Ethnobotany — Washington (D.C.) — Pictorial works. 4. Landscape gardening — Washington (D.C.) — Pictorial works. I. Blue Spruce, Duane. II. Thrasher, Tanya.
III. National Museum of the American Indian (U.S.)
E98.B7L36 2008
973.04′97 — dc22 2008027785

cloth 12 11 10 09 08 5 4 3 2 1
paper 12 11 10 09 08 5 4 3 2 1
Printed in Canada

Contents

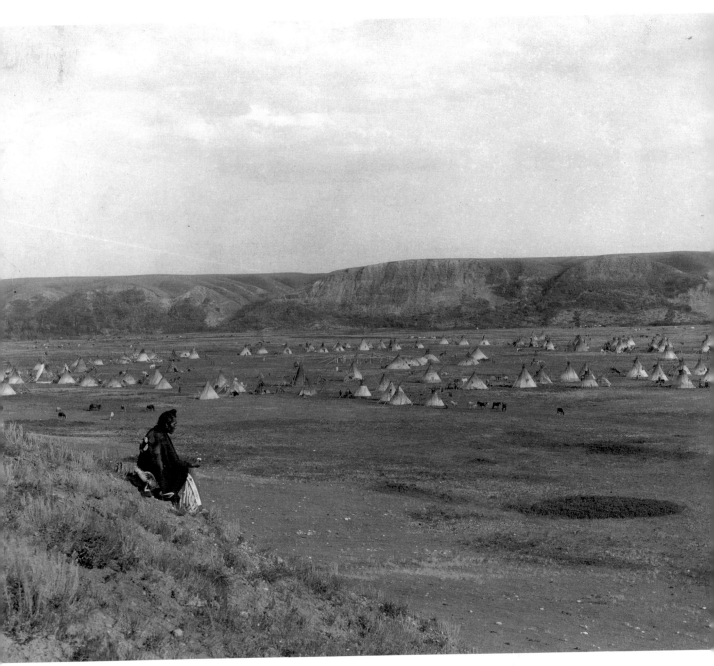

Man sitting on a hill overlooking a Blood, Piegan, and Sarsi encampment,
Alberta, Canada, ca. 1900. P20874

Foreword

Like all mothers, Mother Earth is the ultimate giver. She reveals her beauty in countless variations, from wetlands and meadows to rain forests and deserts. Like any good mother, she does many things at the same time and does them all well. She nurtures us with food crops, heals us with medicinal plants, and sustains us with other natural resources. She teaches us how we should live our lives — *don't take more than you need,* she chides. And like all parents, she shapes her children's lives and their ways of looking at the world in profound ways. When we learn that one of our brothers or sisters — Native or not — is from Texas or Alaska or rural Brazil, we then know something about who that person is and how he or she sees the world. So, just as each generation makes its mark on the land, the land inevitably makes its mark on us.

This is Indian thinking. There are many differences between traditional Native philosophies about the natural world and the Western paradigm that has dominated much of recent life in the Americas. Despite its ancient history, the American landscape has come to be seen, over the last several centuries, primarily as the object of Manifest Destiny and a mere backdrop for American civilization. Both of these ideas seem based on the assumption — completely at odds with Indian thinking — that the land is a passive commodity, a thing that gives only if we conquer it, a thing we can own and exploit to fullest advantage. More recently, though, a growing concern is being voiced about the state of our world. A global ecological movement is building that seeks to respect, honor, and preserve the

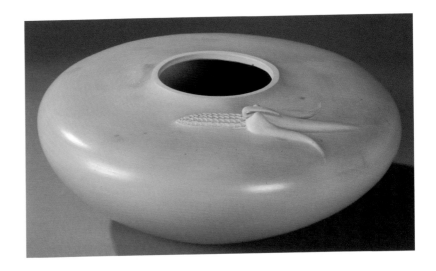

Creamware pot with raised corn design, ca. 1980. Made by Iris Y. Nampeyo (Hopi, b. 1944?), Arizona. 25/4763

health and beauty of our planet. These progressive ideas are in response to cutting-edge scientific research, but they reflect the ancient and deeply held Indian concept that the Earth herself is a living being, sentient and self-aware. Native and non-Native peoples have come to share a concern that our Mother is growing ill and that we must now tend to her with the care and love that she has always shown for us. Through performances, films, and lectures held at the Mall Museum and the George Gustav Heye Center, the National Museum of the American Indian (NMAI) has begun to address global warming and the environment, inaugurating our long-term commitment to participating in this crucial and complex dialogue.

As a window into contemporary Native thinking about the land in general, and the Mall Museum landscape in particular, this book offers a wealth of insights. It also rights a number of misconceptions. Like many things about Indian peoples, our relationships with the natural world have often been oversimplified and romanticized. While we certainly experience very deep connections to our homelands, the image of the innocent primitive frolicking in an unblemished landscape is truly at odds with the reality of countless generations of people who developed sophisticated land-management and agricultural techniques, from the controlled burnings of the North American prairies to ensure better grazing for the herds

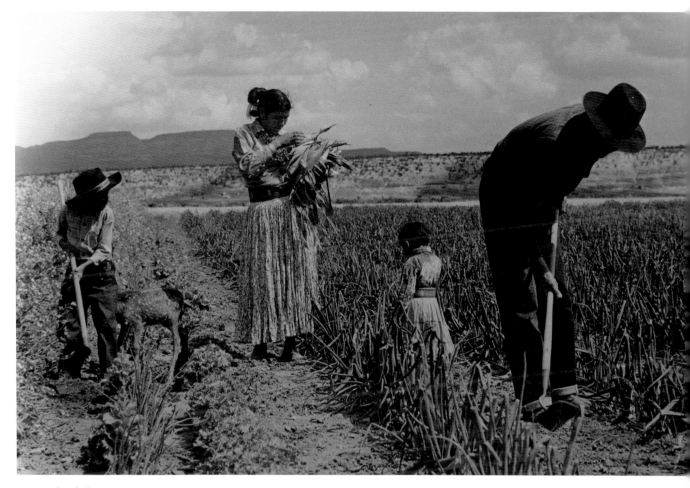

Navajo family harvesting crops, New Mexico, ca. 1952. P32981

of buffalo, to the careful way we harvest sassafras, to the interplanting of corn, beans, and squash. Any Hopi farmer will tell you that corn doesn't just spring from the dry red earth of Arizona, even though it has grown there for thousands of years. It is the result of Native ingenuity, experimentation, and learning about how we should treat the Earth to best experience her bounty.

The following essays work together to provide a most extraordinary map. They decode physical space, bringing to the printed page significant details that otherwise lie hidden in the water, trees, rocks, and plants sur-

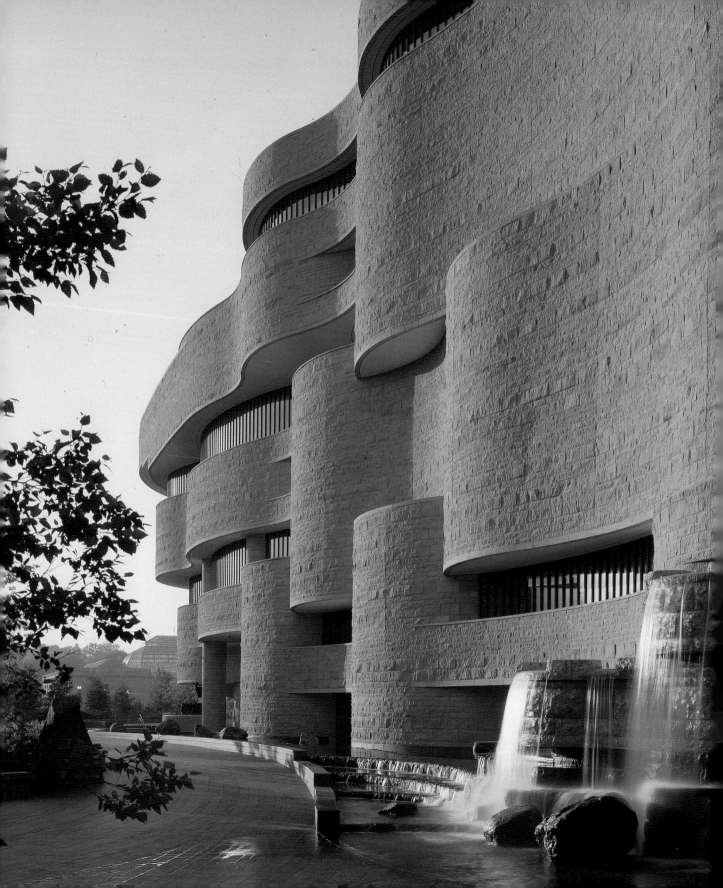

rounding NMAI's Mall Museum. In a larger sense, they are also an atlas to the hearts and minds of a number of contemporary Native people as they construct and deconstruct ideas about their personal relationships to the physical world and to the lands that sustained their ancestors for generations before them. They offer an invitation to see the Mall Museum grounds through the distinctly Indian perspectives from which they were born. To view the landscape through Indian eyes can mean many things. The plantings surrounding the Mall Museum might be seen as a source of medicine and food or as a backdrop for meditation and respite from the city. They could offer a colorful palette that becomes an abstract painting or a piece of beadwork art, or they could provide a setting for remembering the ancestors who came before us.

In the context of the formal geometry of the National Mall, with its carefully tended gardens and uniform rows of trees, we have designed a very different museum site — one that reflects Indian sensibilities. After creating this space in the most culturally careful way we could, we are allowing the landscape, designed to *look* natural, to *become* natural once again. Several years into this process, ducks and foxes are our regular visitors. Hearty indigenous plants, happy to be home again, spread and thrive. To our delight, a barren cypress trunk placed in the middle of the museum's wetlands area has sprouted a new sapling, a magical and humbling example not only of Mother Earth's mysterious generative powers but also of her delightful sense of humor. On lands that have been home to the Chesapeake Bay peoples for thousands of years, a new generation of Native Americans has made its mark on a small corner of our nation's capital. And, true to form, this remarkable site makes its mark on us as well.

— KEVIN GOVER (Pawnee/Comanche)
 Director, National Museum of the American Indian

Always Becoming *sculptures under an American elm in* NMAI's *meadow.*

THE LAND HAS MEMORY

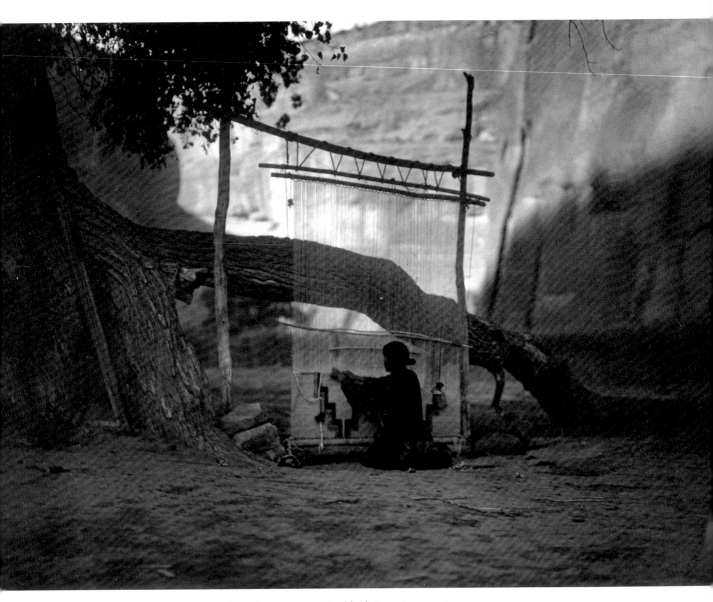

Navajo woman weaving blanket, ca. 1870. P04607

Introduction

REMEMBERING THE EXPERIENCE
OF PAST GENERATIONS

JOHNPAUL JONES

There is no place without a story. Every plant, every animal, every rock and flowing spring carries a message. Native peoples of the Americas learned over thousands of years to listen to the messages, and we know every habitat. We know the earth; we know the sky; we know the wind; we know the rain; we know the smells. We know the spirit of each living place. The spirit of place is embedded deeply within us; we are connected to something larger than ourselves.

In 1993, I joined forces with Donna House (Diné/Oneida), Ramona Sakiestewa (Hopi), and Douglas Cardinal (Blackfoot) to assist in the design phase of the National Museum of the American Indian (NMAI). Through consultations with hundreds of Native elders, artists, educators, and other professionals spanning the entire Western Hemisphere, we attempted to create a building and surrounding habitat that would be imbued with the messages of past generations and the essential spirit of place. We wanted to convey among other things the deep history of Native people here in the area now known as Washington, D.C., and throughout North and South America. We wanted to announce our continued presence: we are still here, even though governments have tried repeatedly to eliminate us. We still practice what our ancestors passed on to us, and our beliefs and traditions live.

It was our firm conviction that we should not simply come and build

The museum should address environments. How many people know there are mountains where you can look without seeing a house, or see the ocean and the horizon? If you don't experience this, you've missed what life is about.

Frank LaPena (Wintu/ Nomtipom), artist, from consultations with Native artists, 1991

Johnpaul Jones (Cherokee/Choctaw) (right) and Founding Director W. Richard West Jr. (Southern Cheyenne) at the outdoor sculpture dedication, 2007.

on the land. We needed to speak to the land first and explain our intentions, promise to use it wisely, and not deviate from that promise. We had to make a pact with the living site, giving it new purpose. We had to ask the earth not to be angry if we dug or removed the soil, and we had to thank it for its sacrifice. In keeping with these convictions, a group of elders walked the site before construction began. They prayed and talked among themselves and found the land's center. Without taking measurements or knowing anything about setbacks or building restrictions, they chose a spot that allowed the maximum use of the ground. The spot also marks the intersection of the site's north-south and east-west access lines. Today, the stone at the heart of the circular floor in the Potomac, the museum's beautiful rotunda, sits at that uniquely identified center point.

Native peoples have an extraordinary relationship with the land and the world around them that stems from the broadest sense of kinship with all life. They possess systems of beliefs that are complex yet straightforward, passed down for generations. My personal beliefs are a gift given to me by my grandmother, taught to her by our Choctaw and Cherokee ancestors,

a way of life revolving around the four worlds of my heritage. An understanding of these four worlds — the natural world, the animal world, the spirit world, and the human world — connects and inspires indigenous people across the Americas while allowing them to have distinct cultures with diverse customs and perspectives. As the NMAI design team contemplated our goals for the museum, we sought to ensure that these four worlds were represented in a very pronounced way, so that from the moment visitors step onto the site, they feel they are in a different place, an American Indian place.

To American Indians, the natural world is distinguished by its cycles, with the seasons of the earth governing all living things. Native communities hold ceremonies to mark each season and give thanks for what the earth has provided. From ancient times, indigenous people have rec-

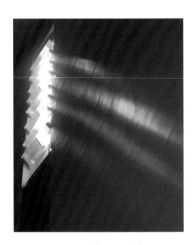

Prisms in the south-facing wall of the museum. This design feature, created by New York artist Charles Ross, reminds visitors of the location and path of the sun.

ognized connections between the celestial world and the cycles of the earth, erecting structures that refer to seasonal solstices and equinoxes and using the moon as a guide for planting and for performing rituals. This sophisticated knowledge of the heavens and how things happen in the universe was something we wanted to make evident in the design of the museum and its landscape.

One day as we met to discuss the building's progress, Donna House asked me to stand with her next to a window. As sunlight poured in through the glass, she placed her closed hand in the light and then opened it so that the crystals she was holding made a rainbow pattern on the ceiling and walls beside us. It was her inspired design concept that led to the magnificent prism window mounted in the south wall of the Potomac. Eight large prisms, each turned to the sun for a particular time of day and season, cast a brilliant solar spectrum onto the floor and walls, blessing all those who pass.

At the center of the Potomac floor, the four cardinal directions and the axes of the solstices and equinoxes are mapped out in rings of red and black granite. The cardinal directions also appear repeatedly outside the museum, notably in the four flat paving stones at the center of the Welcome Plaza and at the edges of the museum site in four stones from Canada, Chile, Maryland, and Hawaiʻi. Forty additional boulders known as Grandfather Rocks, the elders of the landscape, surround the building. They hold the memories of those who came before us and give welcome to visitors.

Fire and water, also fundamental elements of the natural world, are represented in the museum habitat. On the north side of the building, nestled between the wetlands and hardwood forest, a fire pit was constructed for use in honoring and blessing ceremonies. It would not be a Native place without fire and smoke! At the Northwest Plaza, a waterfall grows out of the building's face, seeping between layers of stone. It is a reminder of Tiber Creek, which flowed through this place at another time in history. The land has memory.

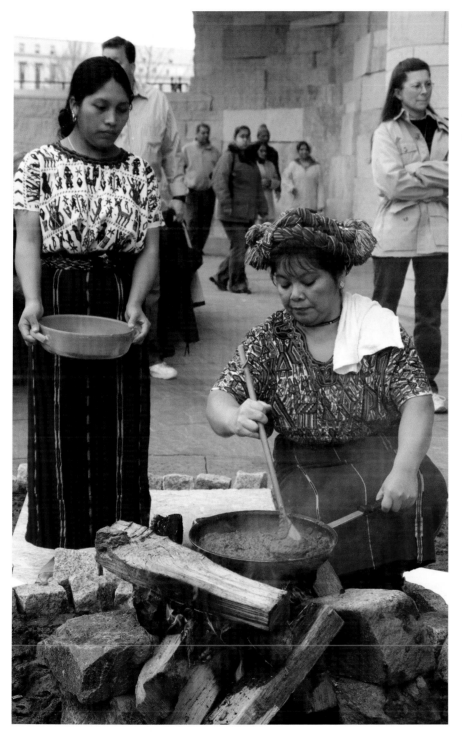

Juanita Velasco (Maya) (right) and Magdalena Ceto Corio (Maya) prepare traditional foods in the museum's fire pit to honor Aval, a Guatemalan corn-planting celebration, 2007.

Native cultures have always had profound relationships with the animal world. Many Native cultures believe that animals are sacred because they have powerful souls; they carry spiritual messages and can possess healing powers. Individual tribes embrace their connection to the earth and all of its inhabitants by honoring the animal life that sustains and informs them. In their crests, the Tsimshian people of the Pacific Northwest pay homage to their animal brothers the Raven, Eagle, Wolf, and Killerwhale. The Haudenosaunee (Iroquois) consider the earth to be a living being, the Great Turtle, with all life riding on her back. We remembered the animal world as we approached the design of the museum, and we wanted to share with visitors our belief in the interconnectedness of all life. To create a wild home for animals on the National Mall, we fashioned wetlands at the eastern end of the site. We envisioned a place where frogs would sing in the springtime, where birds and butterflies would rest, and where trees would remind us of the four seasons of life. Wild rice plants and plentiful nesting spots have brought flocks of mallard ducks to the wetlands habitat. Herons have been seen feeding there, and even an errant fox has come to investigate a landscape that his ancestors would have recognized. In the warmer months, the large building overhang at the Welcome Plaza forms a natural sound amphitheater that resonates with the songs of the abundant animal life in residence.

In the Native worldview, everything is alive, endowed with spirit or energy. Nature has something to teach us, not only through obviously animate things like plants and animals but also through rocks, mountains, rivers, and places large and small. These are all part of our spirit world. Sacred sites, etched in tribal memory, are prized for the forces that abide there and keep things in order and in motion. Native sacred spaces include places of healing, such as springs and waterfalls; places where medicinal plants or special animals may be found; places for celestial observation; and places for dreaming, visioning, and listening to the land. These are the features we undertook to include in the museum and its landscape. The deep significance of sacred sites is present in the Northwest Plaza wa-

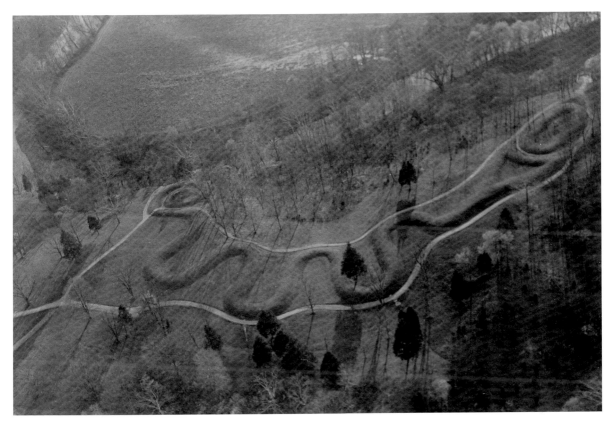

Aerial view of the Great Serpent Mound, an ancient North American sacred site, Ohio, ca. 1935. P18523

terfall, the sound of which echoes off the powerful exposed boulders. The organic pattern of the stone walkways, which recall the bed of a flowing stream, also reminds us of the importance of sacred lands. The nurturing gifts of our land are present in the sunflower, the witchhazel, and the sassafras — plants long recognized for their healing properties — scattered throughout the hardwood forest and croplands of the museum site.

In the early days of the design process, the team traveled across the Americas to hear suggestions from Indian people about how to infuse this new Native place with the spirit of our ancestors and the diverse spiritual traditions of our tribal communities. For example, while few Native American structures have anything close to a dome, many have an open-

ing at the top to release smoke and allow access to spirits. The dome we created soars 120 feet over the main floor and features an oculus or circular skylight — a symbolic passageway for spirits to come and go. The Potomac is the heart of the museum, a space to celebrate the rituals, songs, and dances that keep the Native spirits of the hemisphere alive.

Indian people have often seen museums as dead places that represent Native cultures as relics of some distant past. But the National Museum of the American Indian strives to be a living museum dedicated to transferring knowledge according to ancient traditions, through oral histories, storytelling, performances, and exhibits presented in distinctly Native voices. This is the human world, and it is central to the museum's mission. Grandmothers and grandfathers give us words. Community elders are our first teachers, sharing stories, guiding us, and connecting us to our ancestors and our past. Then one day it becomes our turn to have children all around us, hungering for stories. In the Outdoor Theater, encircled by a flowing waterway, presentations, dances, and musical performances celebrate the power of Native language and knowledge. In this place live the humor, hospitality, prayers, and dreams of our ancestors. We hope that in the future, the landscape will continue to provide a living "stage" for cooking displays; ceremonies involving fire, water, and plant materials; and traditional harvesting demonstrations. Without the ingenuity of Native peoples, we would not have corn chips, guacamole, tomato sauce, or French fries!

The National Museum of the American Indian is a celebration of indigenous peoples' deep appreciation and understanding of the natural, animal, spirit, and human worlds. There is no division between the building and grounds, and the museum itself is centered on that which is common to Indian communities everywhere. It is a place where our beliefs have not been left out, where our ancestors' lessons can be heard. It is a place that marks the other side of an arduous journey of survival. At long last we have an honored place in Washington, D.C., a Native place to tell our stories and celebrate our cultures.

*Music group Na'rimbo
performs on NMAI's Welcome
Plaza during the Indian
Summer Showcase, 2006.*

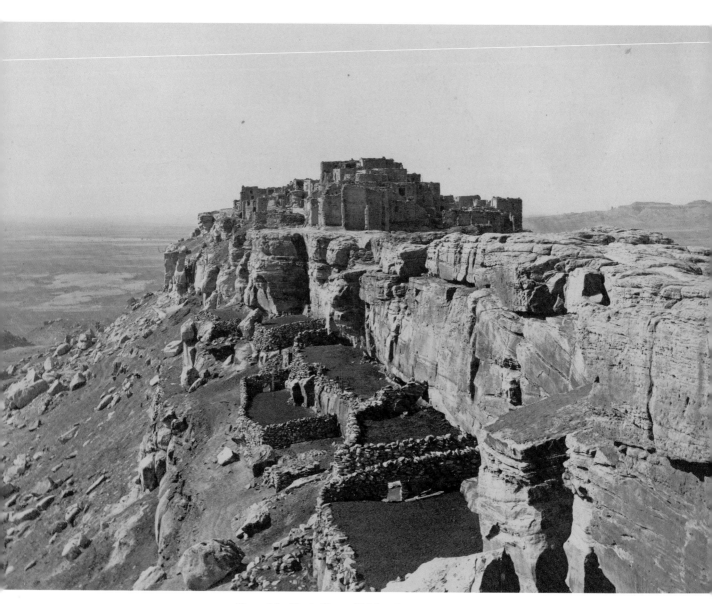

View of the Hopi village of Walpi, Arizona, ca. 1880. P10713

HONORING OUR HOSTS

DUANE BLUE SPRUCE

For Native people, the process of creating something — a meal, a basket, an article of clothing, a dance, a song — is as important as that which is being created. Pueblo people demonstrate this belief in their daily lives, whether they are making loaves of oven bread or hand-coiled clay pots. To make ceremonial or everyday pots and bowls, for example, Pueblo women work together on the arduous task of gathering clay from river-beds and wooded areas and watch their elders to learn which plants to collect for the pigment. They sing songs taught to them by their families, giving thanks for the bounty and honoring the removal of earth and plant life from the ground. Each task is equally important and must be under-taken in the right frame of mind since negative thoughts could destroy a pot while it is being fired. Likewise, in envisioning and developing the National Museum of the American Indian in Washington, D.C., as a truly Native place, everyone who participated treated each step in the process as a significant creative act in itself, guided by a collaborative spirit and following Native protocol throughout the planning and implementation of the project.

Paradoxically, one of the first steps in creating the museum's lush land-scape took place during four days of bitter cold in January 1995, when the museum site was frozen and covered in snow. A vision session had been organized with about two dozen elders, leaders, educators, and artists

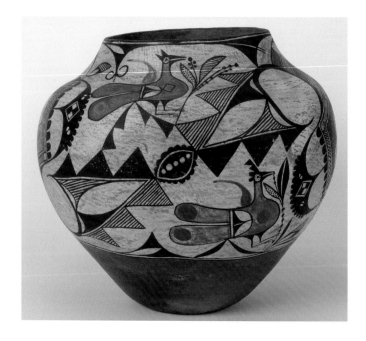

from Native communities throughout North, Central, and South America who had been invited to meet with representatives from the Smithsonian, NMAI, and the building's architectural design team. This session was to build upon the detailed architectural program outlined in "The Way of the People," a document summarizing numerous consultations with Native people and museum professionals undertaken in the early 1990s. Project architect Douglas Cardinal (Blackfoot) and the design team felt that one goal of the vision session was to establish, from the beginning, a decision-making process based on collaboration and community input — to engage dialogue that relied upon many voices. We had set aside four days for the group to discuss the desired attributes of a national Native museum, knowing that the conversation would lead in many directions and offer a multitude of ideas rather than a single, overall concept. While the design team attempted to guide the dialogue, the most important task for all participants was to listen respectfully to each speaker. In addition to pre-

opposite: *East-facing main entrance of NMAI.*

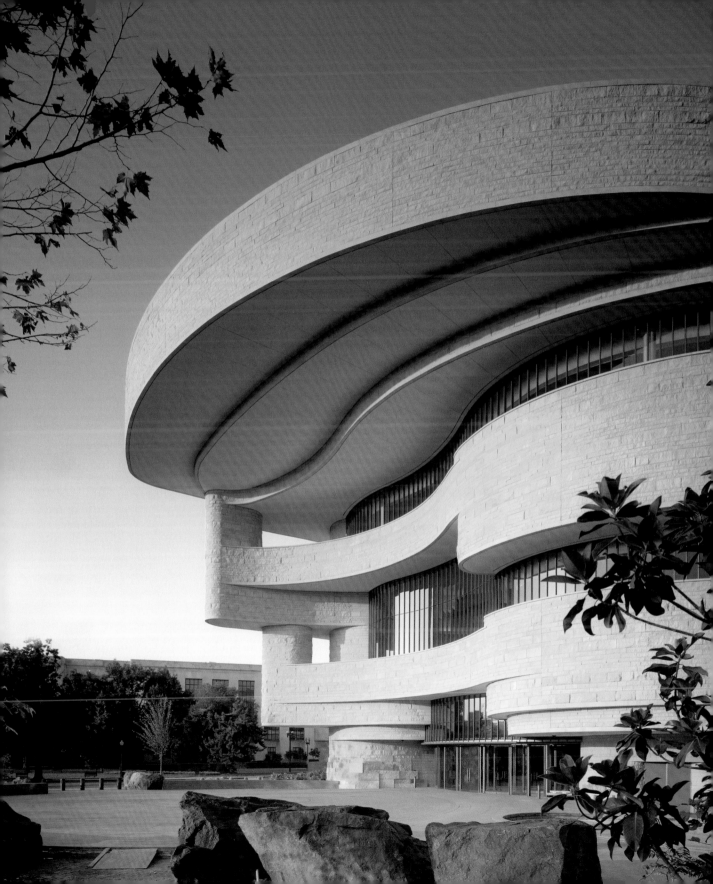

senting their personal histories, the participants related stories from their communities that spoke to who they were and their place in the world.

One of these participants was William Tallbull, a Cheyenne elder and cultural preservationist for the Northern Cheyenne. Like other elders, Tallbull had a tremendous amount of traditional plant knowledge. The eloquence and power of his words resonated with the team and solidified the integral importance of plants and the landscape to the museum's overall philosophy and design. He echoed the sentiments expressed by Native consultants in "The Way of the People," including Santa Clara Pueblo architect and educator Rina Swentzell. She presents her thoughts on the natural world, in part, in the document's preamble: "We embrace the cycles of our organic world, such as days, seasons — and our lives. Our life and death cycles connect us to the cycles of the sky, water, and earth. We honor these cycles in our daily tasks, our subsistence patterns, and ceremonial activities. Our sense of time is in accord with a natural continuum where past, present, and future are interrelated."

Key concepts began to emerge from the vision session, which built upon years of consultations and laid the foundation for the building's landscape design. Four Native advisers who worked with the project team throughout 1995 thoughtfully considered all of the concepts: Arthur Amiotte (Oglala Lakota), Susie Bevins (Inupiat), Lloyd Kiva New (Cherokee), and Alma Snell (Crow). This Native Advisory Group served as the project's cultural advisers, making sure the design remained true to the concepts put forth. They infused the project with a distinctively Native viewpoint by maintaining a collaborative spirit and addressing the myriad design suggestions with an eye toward cultural authenticity. Most important, the landscape would honor the host tribes on whose land the museum was being built by introducing indigenous plants and crops.

The central ideas of the museum landscape were to be conveyed in a subtle, experiential, or affective manner rather than an overtly didactic one. The museum would be designed and built in a holistic way, blur-

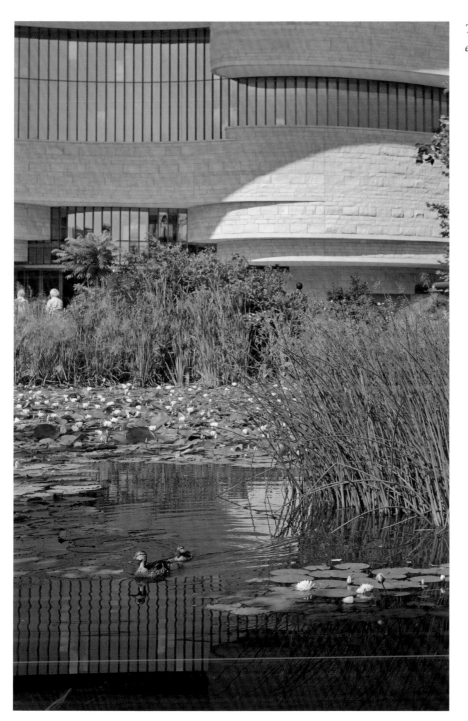

The museum's wetlands environment.

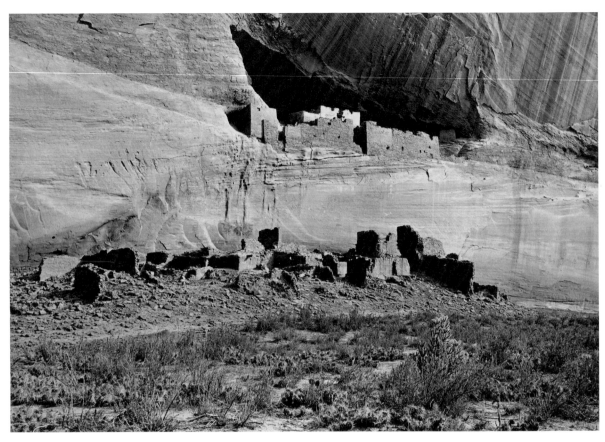

Ruins of cliff dwellings in Canyon de Chelly, Arizona, ca. 1890. P03488

ring the lines between building and landscape, indoors and out. The landscape would reflect a range of natural environments found in the Washington, D.C., region: hardwood forest, wetlands, croplands, and meadow. Clusters of boulders, or Grandfather Rocks, the elders of the landscape, would welcome visitors and convey the longevity of Native people on the land, while a small outdoor amphitheater, a fire pit, an offering area (a discreet place for quiet reflection), and an outdoor welcoming plaza near the main entrance would allow visitors to gather and experience museum programs even before entering the building. Cosmology and Native perspectives on the universe would also play a significant role.

In contrast to the formal, linear patterns and scheduled plantings of annuals (tulips in the spring, chrysanthemums in the fall) on the rest of the National Mall, the environment surrounding NMAI would be dynamic and evolving, with colors and textures reflecting the seasons. Plans for the site were subject to formal review by the National Capital Planning Commission and the U.S. Commission of Fine Arts. Both groups had specified that the building and its landscape should harmonize with the surroundings and acknowledge the significance of the U.S. Capitol, immediately to the east.

The design team conceived of the museum building as a rock formation carved by wind and water, a formation emerging from the earth rather than being set down upon it. To reinforce this idea, the entire base of the building and the surrounding exterior hardscape (the pathways, gathering spaces, seatwalls, and water feature) are built of the same material, American Mist granite. On the curvilinear outer walls of the building, above this granite base, roughback Kasota limestone transitions to a splitface finish, the primary stone finish used. The landscape appears to simultaneously ripple outward from the building and guide the viewer toward it, forming alcoves at the base of the exterior walls for individual and group activities. Granite walkways follow the building's curves, and when pathways intersect, the paving stones appear braided, resembling patterns found in basketry or woven sweetgrass. The walkways continue through the entrances and into the building, where the floor is made of the same granite — another deliberate link between outdoors and in.

As a complement to these general design patterns, specific cosmological references are set into the paving stones at the east and south entrances. The pattern at the east entrance marks the "birth date" of the National Museum of the American Indian by showing the path and location of the planets that were visible above the horizon on November 28, 1989 — the date legislation was signed to create NMAI. The spiral moon pattern set into the pavement at the south entrance refers to major

Close-up view of the Kasota limestone façade of NMAI.

Definitions of Beauty

An imposing structure built in neoclassical style, the U.S. Capitol is set on grounds designed to display it like a temple on a hill. Together, the building and grounds are a symbol of European presence in the Western Hemisphere, and they resonate with Old World romanticism. The Capitol's western façade rises above the National Museum of the American Indian (NMAI), its presence seen and felt from nearly everywhere on the museum grounds. Similarly, the National Mall unfolds alongside NMAI, a tightly designed extension of Capitol Hill, a formal metaphor of obeisance. In sharp contrast to the Capitol and its setting, the museum presents crisp, contemporary forms and organic curves redolent of natural shapes, announcing its own message and character. The grounds of the museum further distinguish it from the Mall's staid surroundings. Nearly 30,000 trees, shrubs, and other plants indigenous to the region create a Native environment as well as an intriguing destination.

The palette of the museum grounds includes stone, water, and plants. Stone, the natural and everlasting material of the earth, is laid out as an extension of the building, its sinuous curves and paving patterns echoing those of the architecture. Water plays many roles here — it activates, humanizes, provides drama, and creates special places by announcing entrance and arrival, leading the visitor into the building, creating figurative and real thresholds, and moving to its own dance. Taken together, stone and water form a pattern and a storyline about human presence and the dynamic ebb and flow of cultures over time. Stone and water are also two of the great design motifs of the National Mall and the District of Columbia. The most notable buildings, monuments, and memorials are all made of stone, and from the earliest days of the capital city's development, water resources have been harnessed in ways that echo the great public water infrastructure of classical Rome.

Plants play a more subdued and less expressive role in the capital city.

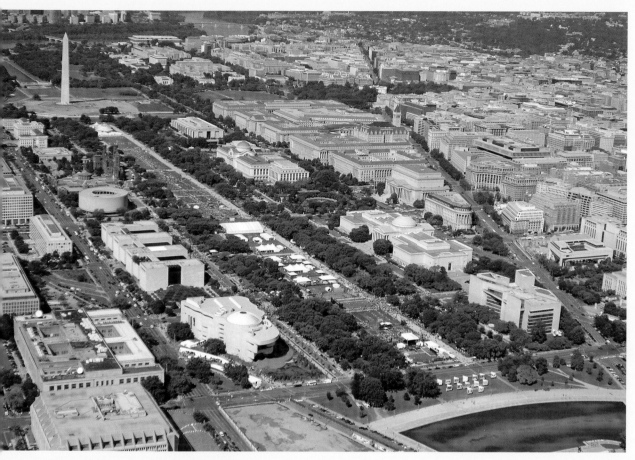

Aerial view of the National Mall looking northwest.

Washington, D.C., is known as the City of Trees, a designation that the local government and the Casey Tree Foundation are working to revitalize. The shade and architectural relief provided by trees and other plantings are important factors in creating a livable city year-round. The National Garden, a relatively recent addition to the Mall located on Independence Avenue across from NMAI, is the primary outdoor element of the U.S. Botanic Garden. Its origins were shaped by Thomas Jefferson and George Washington, both of whom envisioned a garden at the foot of the Capitol where the botanic bounty of the continent would be on

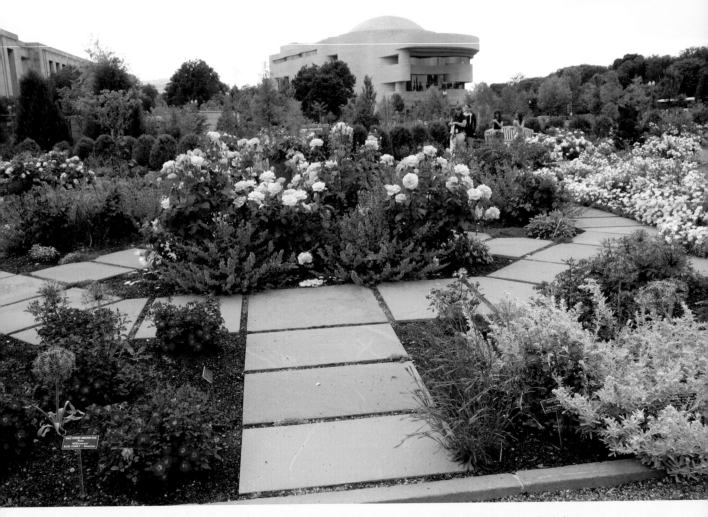

NMAI *as seen from the U.S. Botanic Garden's National Garden, which features a Mid-Atlantic native plant display, summer 2007. Photo courtesy* USBG.

display and available for research. That original objective has been modified — the space is now more decorative than scientific — but the National Garden reaffirms the idea that planted environments provide relief and beauty in an urban setting.

It is serendipitous that these two unique gardens, the NMAI landscape and the U.S. Botanic Garden, today sit side by side. Together, they enrich the National Mall, and their distinctions invite dialogue about plants unique to the Mid-Atlantic region. While the Botanic Garden showcases its 26,000-specimen collection through a variety of educational displays, including the ornamental landscape of the National Garden, NMAI emphasizes indigenous perspectives and the grouping of plants within four regional environments. Despite differences in design approach, both institutions inform visitors about biodiversity, worldwide conservation efforts, and the continued significance of medicinal plants to our daily lives.

While these two specialized gardens place a priority on educating visitors, plants in most of Washington's public spaces, particularly along the Mall, are more often used in formal and architectural ways. An example is the grid of American elms conceived by Charles Eliot that holds sway for the length of the National Mall. Eliot was a landscape architect and the longest-serving senior designer of the McMillan Commission, under whose aegis the Mall was constructed in the early 1900s. Planted in long rows, the hundreds of arching elm trees were specifically intended to create a singular, green arboreal frame for the Mall that no building could interfere with or outshine.

The backdrop for plantings on NMAI's grounds is small when compared with the expanse of elms on the Mall. The scale at which the museum's landscape can be appreciated, however, is what makes the difference. Viewed from a distance, it forms part of a distinctive visual composition, with cascading water and flowing stone walls, inviting the passerby in from the formal and austere grounds of the Mall. Once visitors enter the

museum site, the plantings welcome them to a new experience they can easily feel and see. Almost immediately, questions arise. People instinctively respond to plants — there is a reason gardening is a favorite pastime! With stone and water, plants create the numerous smaller places and moods of NMAI, articulating the museum's extraordinary presence on the National Mall.

The study of plants in the museum garden prompts an especially important question: what constitutes beauty? For many Americans, the answer in landscape terms has always been some kind of designed, organized, or managed composition or environment. Even the National Park System has taken a human-controlled, human-managed approach to territory. Such perspectives are antithetical to Native views of the world. Indigenous teachings emphasize individual definitions of beauty, not centered on control by subjugation and categorization but shaped by a sense of belonging and being an intrinsic part of the natural environment. The grounds of NMAI are not and never will be a "landscape" as originally defined — a European art term for a view that includes nature in some way. In contrast, the plants and their purposeful arrangement across the museum site provide keen insight into a different view of beauty.

— ROGER COURTENAY

lunar standstills — periods of extremes in daily and monthly moonrise and moonset patterns that occur about every nineteen years. Ancestral Puebloan astronomers marked the phenomenon more than a thousand years ago by carving a spiral petroglyph into the rock atop Chaco Canyon's Fajada Butte in present-day New Mexico.

Native people have always revered water as a life-sustaining gift from the Creator. While many Native communities derive sustenance directly from oceans, lakes, and streams, even landlocked communities rely on

opposite: *A spiral lunar pattern marks the museum's south entrance.*

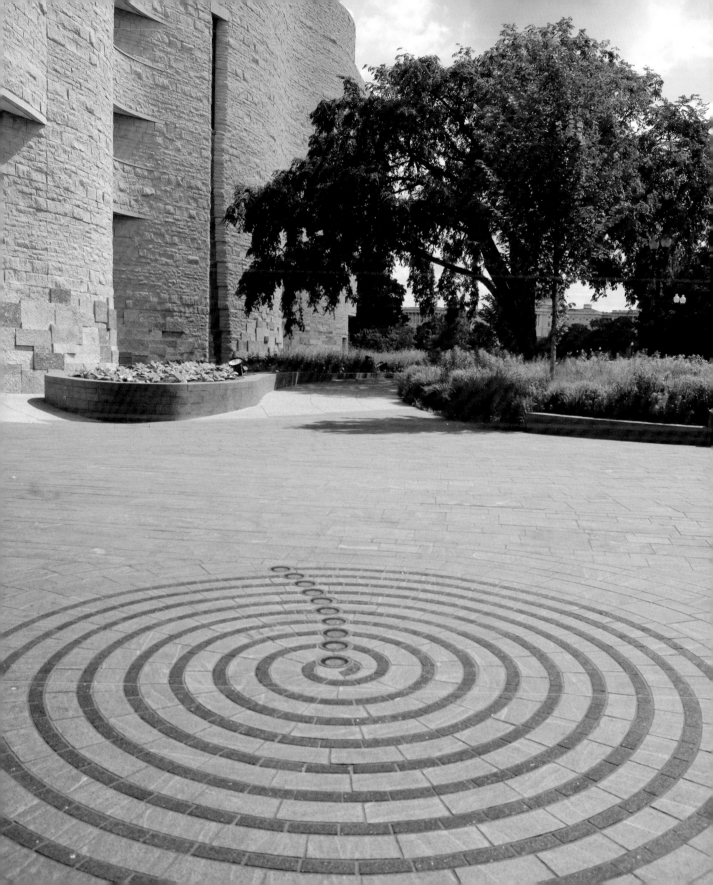

Ancient Pueblo cultures created a celestial calendar at Chaco Canyon's Fajada Butte.
Specially placed stone slabs create distinct shadows of sunlight and moonlight to mark
both solar and lunar cycles.

rainfall and captured water to grow their crops and nourish their live-stock. Water also plays a role in Native ceremonies and rituals as an ele-ment of cleansing or purification. For the Native people of the Washing-ton, D.C., region, an extensive web of local waterways made the area an attractive place to settle and trade. In fact, the original inhabitants named some of these waterways for their uses: *potomac* means "where the goods are brought in" in the language of the Piscataway, and *chesapeake* is an Algonquian word meaning "great shellfish bay."

With these ideas in mind, the landscape's designers made sure that

water was a prominent feature. The waterfall on the northwest corner of the museum site, clad in stone that matches the structure's Kasota limestone, appears as an outcrop of the building's mass. The granite-lined "river" or "creek" element of the water feature is an extension of the building's base. Water flows eastward, to guide visitors toward the main entrance, and southward, to create visual interest for visitors inside the museum. The south-flowing effect is most dramatic for those dining near the floor-to-ceiling windows in the café, where the water cascades toward them and disappears under the floor beneath their feet.

The wetlands area at the eastern end of the museum site provides another way to experience water. Ducks, dragonflies, and birds are frequent visitors, and the look of the habitat changes dramatically according to the season. The wetlands appear to extend around the southeast corner of the building, so that visitors entering from that direction have the sense that they are crossing a bridge. The reeds, grasses, cattails, and other relatively low plantings offer a clear view of the U.S. Capitol dome from the museum's main entrance. This visual connection between the two buildings allows visitors to reflect upon the complex historical relationship between Native people and the U.S. government.

Finding a single source of plants for four distinct habitats proved impossible, so the seedlings, trees, and shrubs came from different nurseries. To show proper respect for the plants, NMAI coordinated with three nurseries in North Carolina, Pennsylvania, and Connecticut and local Native elders in each area, who performed blessings on the plants. A spirit of unity, camaraderie, and cooperation marked the ceremonies — for each participant, it was an honor to be involved in such a unique project with a distinct set of cultural protocols. Led by Donna House (Diné/Oneida), the team planted a total of 27,346 individual perennials of 145 different species in 8 different types of soil on the site.

During the subsequent years, the landscape has matured as the plants have taken root and gone through several seasonal cycles. Crops have flourished in the rich soil next to the building's sun-drenched southern

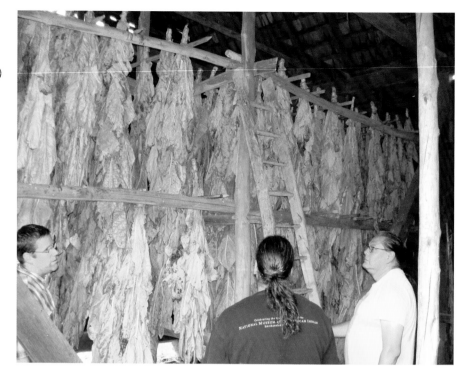

façade. In addition, the Smithsonian's Horticulture Services Division (which maintains the landscape) planted tobacco with seeds supplied by Native sources. The staff harvests the tobacco each year, working with Native peoples in North Carolina and southern Maryland to properly cure and wrap it. The small packages then become gifts from the museum to visiting Native people.

As they did with the plantings, the staff took much time and care in finding a source for the forty or so boulders that would become the museum's Grandfather Rocks. We were unable to find a suitable quarry nearby, so the general contractor identified a source in Alma, Quebec, which was also supplying the project with other granite. With representatives from the quarry, the team visited four sites in Quebec to select stones of various sizes that would complement their settings in the museum landscape. For example, it was important to find a tall boulder with

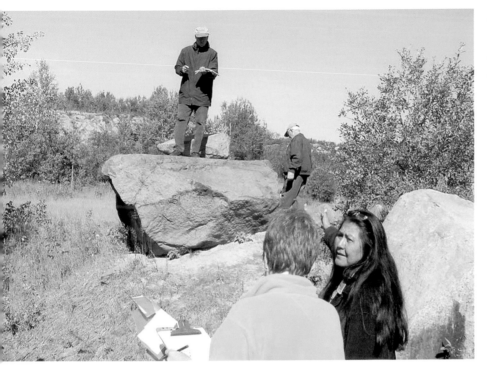

Duane Blue Spruce (Laguna/
San Juan Pueblo) (top left),
Paul Robitaille (top right),
Marsha Lea (bottom left),
and Donna House (Diné/
Oneida) (bottom right)
select boulders at a Quebec
quarry, 2003.

a flat surface to place across from the waterfall so that the sound of the water would bounce off its face and resonate in visitors' ears, an acoustic technique used by the Maya in building their stone ball courts at Chichén Itzá. We selected each boulder with its specific placement in mind, and each was marked so that it would face the same direction in the museum's landscape — north, south, east, or west — that it had faced in its original setting.

In choosing the boulders and preparing them for the long journey to Washington, D.C., the design team also worked with representatives of the Montagnais people of Mashteuiatsh, a local First Nations community in Quebec. At one of the quarry sites, Donna House and the Montagnais group gathered the French Canadian stone workers in a circle and explained the significance of the boulders, distributing corn pollen and offering a prayer. This impromptu blessing ceremony was an example of

how this project introduced a variety of people to Native practices and protocols. This was no doubt the first time those workers had experienced such a ceremony in the course of their work!

The stones were transported from Quebec to the museum site on flatbed trucks in separate groupings. With some boulders weighing as much as several tons, it was a challenge for the contractor to gently maneuver each one into place according to its original orientation. After the first grouping arrived, NMAI conducted a blessing ceremony with members of local Maryland and Virginia tribes to welcome the boulders to their new home.

Rising from the meadow area on the museum's south side, a series of five vertical sculptures suggest both human figures and dwellings. Created by noted sculptor Nora Naranjo-Morse (Santa Clara Pueblo), each figure in the series, entitled *Always Becoming*, is grounded in the environment, its materials meant to change over time in response to the weather and other natural conditions. Naranjo-Morse took great care in placing and sizing the figures, as well as in selecting natural materials for them. She used structural poles cut from Washington-area elm and black locust trees, and she included local soil in the mud-clay mixture that forms the "flesh" of the sculptures. Rocks, pottery shards, and grasses — some from Naranjo-Morse's home in New Mexico — are incorporated into each figure. Like members of a family, each piece has its unique characteristics, but each relates back to the group. In addition, like the stone-clad museum building, the pieces have a timeless quality. Not literally human, the figures represent instead the generations who preceded us. Both cerebral and inspiring, *Always Becoming* is an evolving part of the landscape and aligns beautifully with many of the concepts behind the creation of the museum.

Following nearly fifteen years of detailed planning, building, and planting, the museum's opening in September 2004 allowed the public to *experience* the landscape for the first time. Among the thousands of Native people who participated in the opening procession on the National Mall,

Nora Naranjo-Morse (Santa Clara Pueblo) applies a mud mixture to one of the Always Becoming *sculptures, titled* Gia (Mother).

The Heron's Visit

Ironically, my most memorable experience of the museum landscape occurred while I was indoors in the wintertime. It was a gray day in January 2005 with a light coating of snow on the ground and a thin layer of ice covering the wetlands area. During a meeting break, I looked out of the east-facing window and saw a very large bird swoop down from the north and land gracefully on the icy surface of the wetlands. Judging by his considerable size and distinct color, I quickly determined that it must be a blue heron. Its shape stood out starkly against the largely white backdrop, and it seemed to feel perfectly at home in this frosty wetlands environment. For a time, the heron walked gingerly across the snow-dusted ice on its long legs, leaving unique footprints in the snow. It was a quiet mid-afternoon, and the experience felt particularly personal since I was sure I was the only person watching this graceful figure. The heron suddenly flapped its large wings and took off, heading south. As I watched its soaring figure disappear into the gray skies, I recalled another January day ten years earlier when I joined a group of elders, friends, and colleagues on a cold walk across the very same spot. Then, the site was just an anonymous snow-covered patch of grass, and we were envisioning the museum for the first time. I wondered if one of the elders who joined me that icy day years ago had seen the heron's visit long before I had.

— DUANE BLUE SPRUCE

there was a tremendous sense of homecoming and welcome. In those early warm autumn days, hundreds of visitors relaxed along every seat-wall, enjoyed the resident ducks swimming in the wetlands, touched the Grandfather Rocks, and marveled at the view of the U.S. Capitol. While elders quietly left small offerings in the offering area, children noisily ran their fingers through the water feature. The landscape proved to be a venue perfectly suited to such a festive occasion.

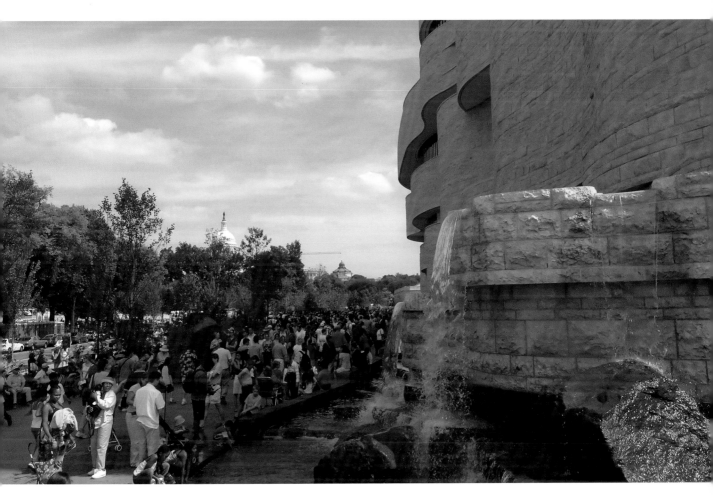

Opening day at the museum, September 21, 2004.

Having been involved with the design process from its earliest days, I feel that we created an environment that was guided by Native thinking. It was a tremendous accomplishment, given the high hopes and expectations placed on it by Native communities throughout the Western Hemisphere. For everyone who worked on the landscape, each aspect of its creation — laying stone pathways, digging out the wetlands, planting seedlings and trees, transporting boulders — carried its own significance. By following Native principles and protocols, we created a truly Native means of honoring our original host, the land itself.

The southern marker in NMAI'*s meadow.*

CARDINAL DIRECTION MARKERS
BRINGING THE FOUR DIRECTIONS TO NMAI

JAMES PEPPER HENRY & KRISTINE BRUMLEY

Nearly every culture on earth has a concept of the cardinal directions: north, east, south, and west. A basic means of establishing geographic orientation, they are known as the Four Directions to many indigenous peoples throughout the Americas and are represented in ceremony, art, clothing, and architecture.

The Four Directions have greater significance beyond their practical function. They are imbued with metaphor and supernatural powers that relate to our existence as human beings. Many Native peoples associate colors, seasons, and animals with the Four Directions, associations that form the basis of an indigenous philosophy known as the Medicine Wheel. Each direction of the Medicine Wheel has a specific meaning that varies from community to community. For example, some Native people believe that north corresponds to the color white, suggesting the winter season and its qualities of cleansing, endurance, and wisdom. Some Plains tribes associate the sacred animals White Eagle and White Buffalo with the north. East is often connected to the color red — the spring season and the rising sun, representing peace, light, and new life. The revered Spotted Eagle is often associated with the east. For some Native communities, south corresponds to the color yellow and the summer season, representing warmth, understanding, and humility. The Golden Eagle and Coyote are sacred animals often associated with the south. Many Native

This stone [the southern marker] is a symbol of our people. Our people are slowly vanishing, but this stone will be our ambassador to Washington and remind people from all over the world that we still exist.

Patricio Chiguay, president of the Yagán community, 2004

people connect west to the color black, the fall season, and the setting sun, representing finality and introspection. The Bald Eagle and Bear are often associated with the west. Some believe that the Four Directions also equate to the four stages of human life (birth, youth, adulthood, and old age).

The confluence of the Four Directions is the center point, which represents balance. Many indigenous religious beliefs and practices encourage human beings to find balance in life with regard to the lessons of the Four Directions. If there is too much emphasis on one direction or another, it is believed, a person risks shifting his or her life out of balance.

The theme of cardinal directions is one that resonates with many who visit the National Museum of the American Indian. The museum's planners agreed that four special stones would be placed at the four exterior cardinal points of the museum landscape to physically represent the cardinal directions. These stones would "anchor" the museum to the site,

creating balance and representing Native people from the four directions of the Americas.

Originally the strategy was to acquire four large boulders from within the contiguous United States, but this idea was eventually expanded to include the entire Western Hemisphere and Hawai'i. A team of Smithsonian staff established the criteria for the selection of the Cardinal Direction Markers: the four stones had to be selected by Native communities, ensuring respect for the cultural authority of indigenous peoples while maintaining the stones' integrity; and the acquisition process needed to avoid altering the land from which the stones originated. As with the placement of the museum's Grandfather Rocks, each marker stone's original orientation in the landscape would be recorded so that it could be approximated in its new home.

Team member Tim Rose, Smithsonian mineral sciences geologist, suggested using stones from different epochs in the earth's geological life cycle as a metaphor for the human life cycle. This approach was consistent with the concept of the four stages of life and helped to narrow down potential sources of stone and their corresponding Native communities. Finally, the team considered diversity in the composition of each stone.

A brief geological survey of the hemisphere yielded four potential sources of stone that met the criteria of cultural relevance, geographic variety, and geological diversity: Northwest Territories, Canada (northern marker); Monocacy Valley, Maryland (eastern marker); Isla Navarino, Tierra del Fuego, Chile (southern marker); and Hawai'i Volcanoes National Park, Hawai'i (western marker). The team spent several months securing permission to travel to these locations and develop partnerships with the communities for the acquisition of the stones.

It was critical for the team to understand cultural perspectives when approaching Native communities. They took special care to avoid acquiring any stone with possible historical or archaeological significance or with specific ceremonial associations. They also sought to preserve each stone in its natural condition. One important cultural perspective

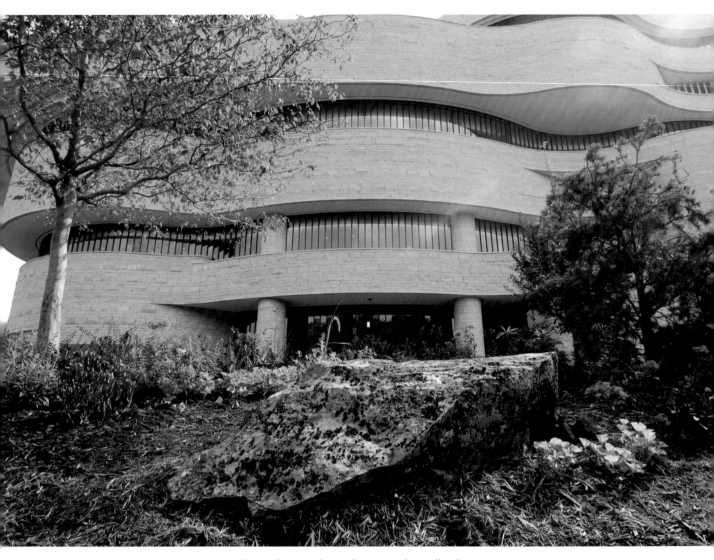

The northern marker in the museum's woodlands.

that the team addressed was concern about the "void" left behind by the stones removed. A piece of Kasota limestone, the same stone of which the museum is constructed, was given to each participating community in a symbolic exchange.

The oldest known deposit of stone on earth is found on a peninsula of Acasta Lake in Northwest Territories, Canada. The stone, known as Acasta gneiss, is approximately 4 billion years old (Precambrian era) and represents the planet in its youth. With the help of the Canadian government, the team identified the Tlicho (Dogrib) community of Behchoko to sponsor the selection of a northern marker from this deposit. They had recently signed a treaty with the Canadian government giving them territorial rights to the area encompassing Acasta Lake.

The team worked closely with the Tlicho community, mineral rights holder Jack Walker, several Canadian-based organizations, and the Canadian Embassy in the process of identifying, selecting, and extracting the stone from Acasta Lake. To make the final stone selection, the NMAI team traveled to Acasta Lake by floatplane with a small delegation, including Jon B. Zoe, the chief negotiator for the Tlicho Treaty 11 Council, and Henri Simpson, a Tlicho elder. Using only tape measures and on-the-spot calculations, the scientists accompanying the group had to approximate the weight of various stones to identify those that could be carried by helicopter. Zoe made the final choice, a stone weighing approximately 1,600 pounds, and Simpson performed a ceremony in honor of the stone's selection. The stone was airlifted to the city of Yellowknife, where it was loaded onto a flatbed truck and driven to its new home.

In late January 2004, the Smithsonian team traveled to Tierra del Fuego in southern Chile to ask for the participation of the Yagán, the southernmost indigenous community in the world, in the selection of the southern marker. The team journeyed to Bahia Mejillones (Mussel Bay), the ancestral land of the Yagán, where the community selected a large boulder sitting on a grassy slope overlooking the water, facing northward across the bay to Argentina. The stone was estimated to be from the Cretaceous

Preparing the Plants

"You should go outside and feel the grass under your feet, play in the dirt, go swim in the river. This will take care of anything that ails you." When I was eight years old, this was the advice my aunt offered as a cure for the restlessness and boredom of long summer days. I sought shade at the base of an oak tree whose unearthed roots formed a cradlelike seat around me and dug my toes deep into the cool, rich Robeson County soil. My mother, aunts, uncles, cousins, grandparents, and neighbors had all worked this farmland of eastern North Carolina, cropping tobacco and bailing cotton. At the time, I did not understand the importance of the soil, nor my family's respect for our land, the nearby river, and the plants that appeared year after year, seemingly without effort.

Thousands of plants such as cotton and tobacco have sustained Native communities in countless ways — economic, social, medicinal, nutritional, cultural, and recreational. Until recently, tobacco and cotton were the primary cash crops for many Lumbee people. A cotton or tobacco crop determined whether a family's year would be one of feast or famine. Entire families and their neighbors worked together to "crop" tobacco or "bring in" cotton during harvest time, rotating to each farm to finish in time to go to market. This type of community support over generations built lasting bonds that still prove invaluable. Although the Lumbee are no longer primarily agrarian, we still honor those family relationships and commitments, supporting one another in community and business collaborations.

When the design plans were released for the National Museum of the American Indian (NMAI) in the early 1990s, many in our community were particularly curious about the landscape. I imagined it would be a formal, manicured setting of flowers, trees, and sidewalks, much like the rest of the National Mall. Luckily, I was one of the first in the community to learn otherwise. One day while at work at the Metrolina Native

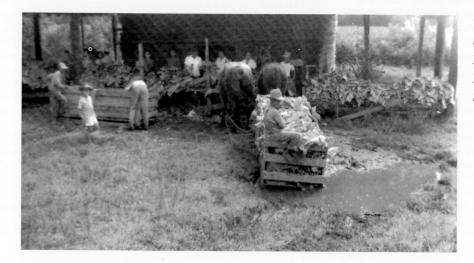

The Bullard family's annual tobacco harvest, North Carolina, 1959. Photo courtesy Nancy Strickland (Lumbee).

American Association in Charlotte, North Carolina, I received a call from Duane Blue Spruce (Laguna/San Juan Pueblo), an architect and the primary construction liaison between the museum and its architectural design team. He asked for my assistance in contacting herbalists and elders from the area to participate in a blessing ceremony for plants and seedlings from a local nursery that were to be a part of the museum landscape. He explained that the landscape would be a strictly indigenous setting that would evoke regional environments that existed before European contact.

I recall hanging up the phone, delighted that the museum's architects and planners had incorporated this concept into the overall design. By featuring a variety of trees, shrubs, wildflowers, and crops — including tobacco — the museum's grounds would represent the experience and understanding of Native peoples. This approach would honor and reflect not only the architecture but also the objects housed within the building.

Immensely proud to be involved in the project, I contacted herbalists and elders from my own and neighboring communities. Keith Brown from Catawba, Freeman Owle of the Eastern Band of the Cherokee, and Earl Carter, a Lumbee, agreed to conduct a ceremony that would em-

39

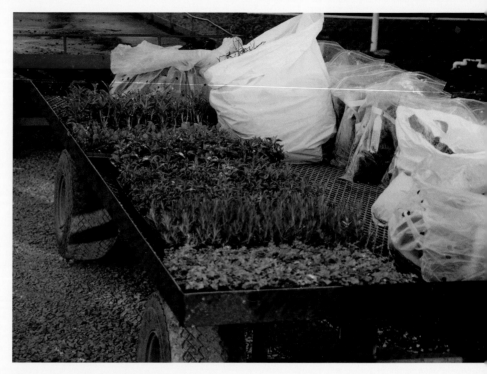

Plants and seedlings for the blessing ceremony.

power the plants to fulfill the awesome responsibility charged to them. On a humid May morning in 2003, we gathered at sunrise at a plant nursery in Monroe, North Carolina, some participants with sleepy children in tow. Hundreds of seeds, seedlings, and mature plants intended for a portion of the museum's landscape, including shootingstar, black-eyed Susan, and violets, were neatly arranged on a flatbed trailer.

For the blessing, the nursery staff joined members of the NMAI design team, including Duane Blue Spruce, Marsha Lea of EDAW landscape architects, and Donna House (Diné/Oneida), whose original vision for the landscape was finally taking shape. Although clearly confused about the events taking place, the young men from the nursery removed their hats and stood reverently. Each elder offered powerful prayers as Earl Carter used an eagle feather to anoint each plant and participant with water.

Donna House concluded the ceremony, offering a blessing with blue cornmeal from her home in New Mexico. With a joyful smile, she tossed the cornmeal over the plants and each of us. I remember noticing that the water and cornmeal had made a "batter" on the nursery employees' shirts and in their hair. That was a great sign — the prayers had stuck!

Today, these Native plants are a vibrant life source for the museum's magnificent place in our nation's capital. The plants blessed in North Carolina soon joined varieties from two other nurseries in Pennsylvania and Connecticut. In each location, the seeds and young plants had been prepared for their journey with blessings from Native peoples of the area. In their new home, these living beings have created a fertile foundation for educating visitors, much like the one provided to Native people for centuries. Their roots reach under the stone and steel and connect the museum firmly to our collective heritage. Their pollen brings new life to each visitor, and their foliage provides medicine and comfort to this important place, which retains so much of our history.

I now work at the museum and enjoy the opportunity to reconnect with the familiar plants from home. Every day, I notice how black-eyed Susans populate the meadow and wild strawberries grow thick in the forest area, flourishing in the blessings offered years ago. There are signs that all of the landscape plants are at work: people harvest and use the tobacco, eat the crops grown with the help of insect-eating ladybugs, and enjoy the cool shade of the trees in the forest. This truly is a Native place.

— NANCY STRICKLAND

The Yagán honored the departure of the stone they selected for the southern marker from Chile with a community picnic and farewell.

The southern marker in NMAI's meadow.

period (between 65 and 145 million years old). The stone's 18,000-mile international journey began with the short trip from Mussel Bay to Puerto Williams, a seaport town on Isla Navarino, Chile, where the 7,000-pound boulder was unloaded and placed in a sea container. It was then shipped by boat to the Baltimore Harbor and transported to Washington, D.C.

The youngest of the four stones is a lava ball from the Keamoku Lava Flow at Hawai'i Volcanoes National Park near Hilo. Shaped like a giant bowling ball, the stone is estimated to be between 300 and 400 years old (Quaternary period). In November 2003, the team met with the Volcano Kupuna, a council of Native Hawaiian elders who oversee cultural activities at Hawai'i Volcanoes National Park. After some discussion, the Kupuna representatives explained that stones are the body and living spirit of Pele, the volcano goddess. They believe that it is taboo to remove stones from the Hawaiian Islands, and those who do so without permission face retribution from Pele.

Several months later, the team returned to Hawai'i at the request of the Kupuna, who explained that a ceremony existed to temporarily remove the stone from the Kilauea Volcano. The Kupuna selected a stone for the western marker and named it Kane Po, meaning "light and dark," during a special naming ceremony. Like many Hawaiians who travel to the "mainland" to study and work for a time, the rock would return home after a period of twenty years. A new stone from another island would be selected to take its place, continuing the cycle and relationship. After a Kupuna ceremonial blessing, the 4,000-pound stone was transported to the harbor in Hilo and placed in a sea container. It was shipped from Hawai'i to Oakland, California, where it was unloaded and driven across the country.

In May 2004, representatives of the Maryland Commission on Indian Affairs and the Virginia Council on Indians visited Sugarloaf Mountain in the Monocacy Valley near Dickerson, Maryland, to help locate a quartzite stone as the museum's eastern marker. A strong and durable stone, quartzite was highly prized by Native peoples of the Mid-Atlantic region

The western marker decorated with leis during the stone's dedication ceremony, 2004. Native Hawaiians believe that puhaku (stones) are living beings.

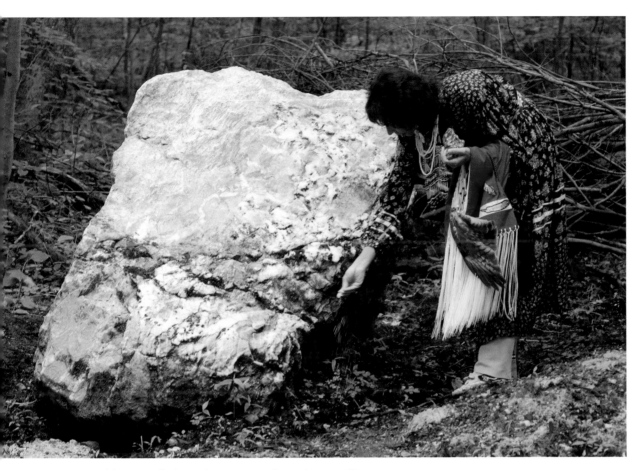

Karenne Wood (Monacan) blesses the eastern marker with corn pollen, 2004.

for making arrowheads and ceremonial items. Karenne Wood (Monacan) conducted a ceremony to bless the 544-million-year-old (Cambrian period) boulder, acknowledging the stone's significance in representing indigenous peoples from throughout the area. Following a trip by flatbed truck to the museum, the 5,000-pound boulder was positioned to face the Capitol building — a location intended to encourage continued positive relations between local Native peoples and the U.S. government.

The most obvious representation of the cardinal directions can be found embedded in the floor of the museum's Potomac, where a large recessed

The eastern marker in NMAI's wetlands.

circle is divided into quadrants of hardwood and oriented on north-south and east-west axes. In the center is a smaller circle of red sandstone, which represents the literal and metaphorical heart of the museum. It also marks the point of convergence of the four Cardinal Direction Markers found in the landscape — if a straight line was drawn from each stone through the walls of the building to a center point, that point of convergence would be the red sandstone circle in the middle of the Potomac. This center stone was quarried from Seneca Creek, Maryland, and it was used to construct the first Smithsonian building, known as "the Castle," which was completed in 1855. It is very fitting that NMAI, one of the newest Smithsonian museums, has at its heart the stone used to construct one of the first museum buildings in Washington, D.C.

Buttonbush in NMAI's wetlands.

ALLIES OF THE LAND

GABRIELLE TAYAC

Late spring on Nanjemoy Creek brings mayflies and a wave of swampy heat that hints at the long, humid summer to come. It also brings my extended family together every Memorial Day weekend. We gather to camp on a home base belonging to Calvert Posey, a lifelong friend of my late grandfather, Turkey Tayac. This year Cal is no longer with us in corporeal form, having passed into the spirit world over the winter. He has joined the legion of ancestors who I believe spiritually guard this land, one of many living beings intertwined over millennia at this place. I feel the vacancy and sadness that many of us feel when a good friend departs, but looking up into trees framed by blue sky, I catch a glimpse of a mother osprey guarding her chicks, and the continuity of goodness is affirmed once again.

Cal was a descendant of one of the original white families who settled on lands belonging to the indigenous Piscataway Chiefdom. Different from many of his peers, he sought to understand the profundity of time's effects on the land and the human changes wrought upon the ancestral landscape. Cal spent a lifetime observing and exploring a complex estuarine ecosystem that was the site of radical transformations generations before his birth and over the course of his life rapidly declined. He passionately pursued archaeology, yearning to reveal what violently silenced Native voices could not tell. Going even further, he forged an enduring,

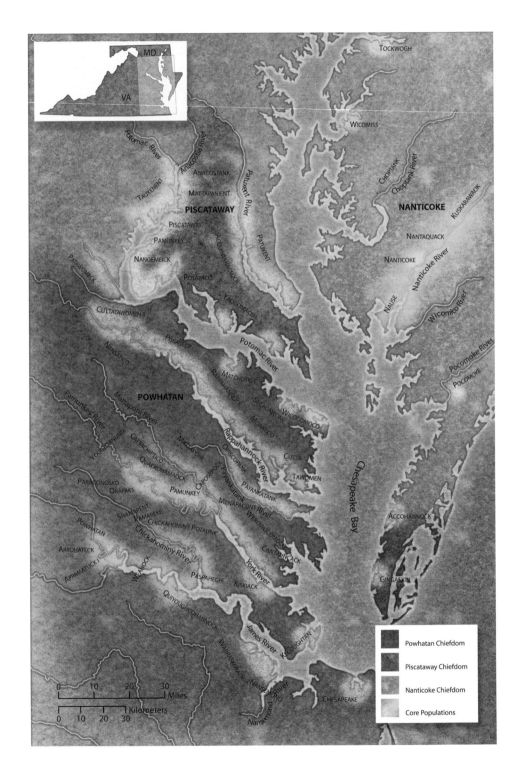

Map of Native communities of the Chesapeake Bay region, ca. 1610.

TOCKWOGH

MD.

VA

WICOMISS

Potomac River

Anacostia River

ANACOSTANK

Patuxent River

MATTAPANIENT

CHOPTANK

Choptank River

KUSKARAWAOK

PISCATAWAY

NANTICOKE

PISCATAWAY

TAUXENENT

PAMUNKEY

ACQUINTANACKSUCK

NANTAQUACK

NANGEMEICK

PATAWOMECK

POTAPACO

Nanticoke River

NANTICOKE

YAOCOMSCON

CUTTATAWOMEN II

Potomac River

NAUSE

WICOMICO River

PISSASECK

Pocomoke River

Pamunkey River

NANSATICO

MATCHOTIC

POCOMOKE

Mattaponi River

POWHATAN

RAPPAHANNOCK

SECACAWONI

MORATICO

WICOCOMOCO

YOUGHTANUND

CATTACHIPTICO

QUACKOHAMAOCK

MANGONI

Rappahannock River

CUTTA

TAWOMEN

PARAKONOSKO

CROSBYOCK

OPISCOPANK

ORAPAKS

PAMUNKEY

PAYANKATANK

PAMAREKE

SHAMAPENT

MENAPACUNT River

WERCHOCOMOCO

ACCOHANNOCK

POWHATAN

CHICKAHOMINY

POTAUNK

CANTAUNCACK

ARROHATECK

WEANOCK

Chickahominy River

York River

APPAMATUCK I

PASPAHEGH

KISKIACK

GINGASKIN

QUIYOUGHCOHANNOCK

James River

KECOUGHTAN

Chesapeake Bay

WARRASKOYACK

NANSEMOND River

CHESAPEAKE

Nansemond

■	Powhatan Chiefdom
■	Piscataway Chiefdom
■	Nanticoke Chiefdom
■	Core Populations

0 10 20 30 Miles

0 10 20 30 Kilometers

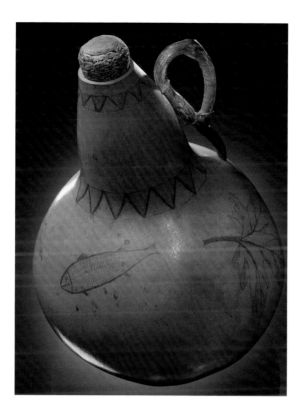

Nanticoke gourd jar with fish motif, early 20th c. Made by Oscar Wright (Nanticoke), Indian River, Delaware. 21/2681

genuine friendship with living Piscataway people. All of this was done in a time before the ecology movement and for the most part before the value of Native culture was recognized by contemporary society.

One afternoon over Memorial Day weekend, as children dig black-streaked clay on the shore and mound it in the sand, I turn to an ongoing conversation with Rick Posey, Cal's son, who still lives on the family's land. Rick explains that Nanjemoy Creek, which actually looks like a wide, shallow, muddy river, does not look like it did in his father's younger years. None of the adjectives that I use here to describe this place applied at all, even a hundred years ago. And these words certainly would not have described the landscape 400 years ago, before the English came and forcibly evicted the Nanjemoy people, a tribe that belonged to the Piscataway Chiefdom.

At that time, Nanjemoy Creek was narrower, deeper, and clearer. Ships

could even travel through the Nanjemoy and other tributaries to the Potomac River. The marshes were not mucky at all; a horse could be ridden through the reeds that now stand in quagmires along the river's inlets. The woods were extensive before Contact and characterized by massive old-growth trees, but from the early 1600s through the mid-twentieth century, they were cleared so that the water could be viewed from houses, set in a landscape of rolling cultivated hills. I close my eyes and try to imagine the land as it was, with dolphins swimming up a river of deep, crystalline waters, and I revel in the fantasy that there were no mayflies. But then one bites me on the neck, reminding me that nature has always offered both ups and downs for humans.

The events that unfolded at Nanjemoy came to pass throughout the Chesapeake region. Among the bay's numerous tributary rivers are the Potomac and the Anacostia, which converge in Washington, D.C., home of the National Museum of the American Indian. From the time when the Piscataway maintained the landscape to the present day, this Native land has changed, declined, and emerged in recovery. I keep in mind that the land recalls our history. The land remembers Cal Posey, and old wounds begin to heal through tenacious alliances with humans like him and my grandfather.

FROGS, SHARKS, AND THE EOCENE COASTAL SEA

A bit north of Nanjemoy Creek is a place that my family calls the Huckleberry. Located in Port Tobacco, Maryland, the Huckleberry is adjacent to St. Ignatius Catholic Church. In the 1640s, the Piscataway at least nominally converted to Catholicism on this site, and many still attend church at St. Ignatius. On August 29, 1895, it rained so hard here that little frogs took over the land. People remember this day as Frog's Day. I also observe this day as the day that my grandfather was born at the Huckleberry.

A little past St. Ignatius on a winding country road is a Jesuit retreat house on the high cliffs overlooking the Potomac. If you follow a steep

path down to the shore and spend a few minutes combing through the gravel, you will surely find fossilized sharks' teeth. The Piscataway used them to make impressions on their pottery, and hunting them has been an absolute delight for generations of children on these Potomac shores.

What are fossilized sharks' teeth doing in southern Maryland, one might ask, and a cosmic event answers back. About 35 million years ago, a comet collided with our planet 130 miles southeast of modern-day Washington, D.C. The impact site, known as the Exmore Crater, stretches fifty-five miles in diameter. Scientifically speaking, this began the series of geologic changes and transformations that led to the Chesapeake Bay we know today. For a time after the impact, the cliffs at the Huckleberry were the floor of the Eocene Sea, where millions of toothy sharks left their evidence for us today. The land remembers turbulent creativity, and it allows us to listen.

UTTAPOINGASSENEM, OUR FOUNDING FATHER

Just a moment ago in geologic terms, or a very long time ago in terms of indigenous narrative, another momentous impact was felt south of the place now known as Washington, D.C. An Algonquian-speaking leader named Uttapoingassenem arrived with his retinue, dramatically changing the human way of life on the Chesapeake's western shore and signaling an era of centralized government. Uttapoingassenem had left the Chesapeake's eastern shore and his Nanticoke countrymen to establish a new chiefdom among the various peoples who had lived for millennia on the western shore of present-day Maryland. He came to be known as the first *tayac*, or paramount chief, among the Piscataway affiliated societies.

Uttapoingassenem encountered peoples who had fashioned increasingly complex lifestyles over the previous 11,000 years. Like his own forebears, the people of the western shore had gradually changed from being nomadic hunters of large game (mammoths) to seminomadic hunter-gatherers to settled agriculturalists. Extended families lived in mat-

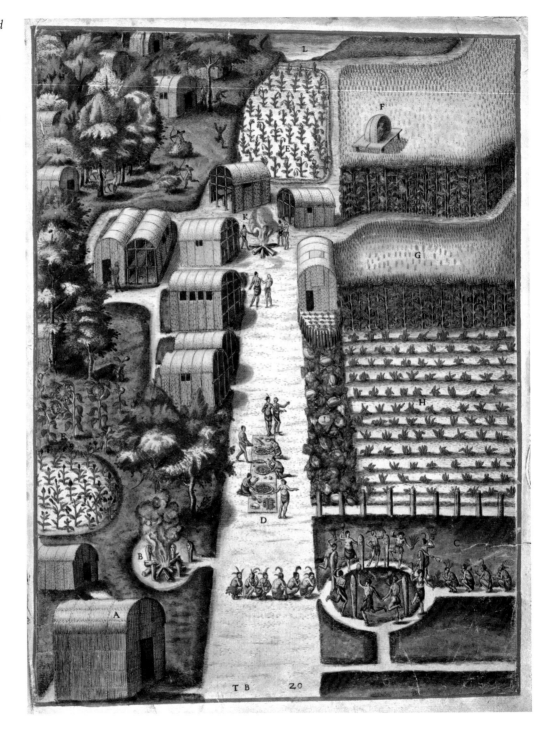

Hand-colored engraving by Theodor de Bry after The Town of Secota *by John White, 1590.*

covered longhouses called *witchotts* in settlements ranging from large stockaded towns to casual little hamlets.

The first *tayac* established his seat of government on the Potomac River in a location that today directly faces George Washington's estate at Mount Vernon. Uttapoingassenem's councillors formed a parliament called the *matchcomoco*, which likely means "big house." Internal civil affairs were dealt with by councillors known as *wisoes*, while advisers on foreign relations were called *cockarouses*. Some believe that this title is the source of the modern English word "caucus," permitting us some insight into the way Native decisions were made. Each of the tribes overseen by Uttapoingassenem was led by a *werowance* (if the chief was a man) or a *werowansqua* (if the chief was a woman). These chiefs were sometimes direct relatives of the *tayac*, but they were free to make autonomous decisions with their local advisers. Their people traveled easily along the many rivers and creeks and were not isolated from each other.

Residents of the Piscataway Chiefdom societies certainly had an impact on the land, but it was undoubtedly gentler than that of the English colonists. Contrary to popular notions of the noble savage roaming haphazardly in wild nature, the Piscataway carefully managed their relationship to the Chesapeake environment in a sustainable way. The small-scale cultivation of diverse crops allowed the preservation of the old-growth forests that constituted about 98 percent of the Piscataway homelands. Extensive wetlands areas cleansed debris before it went into the rivers, creating waterways that were deeper and less saline than they are now. The forests and wetlands greatly slowed natural erosion processes, so there was more actual dry land in those times. Today, half of Moyaone — formerly the center of the Piscataway Chiefdom, now known as Accokeek, Maryland — is underwater due to rapidly increasing erosion.

Piscataway men deliberately sculpted the forests through controlled fires. Managed fires cleared the underbrush, opening the woods for deer and other game that offered their lives for human sustenance at the urging of the Living Solid Face spirit. In return, the people tried to take only

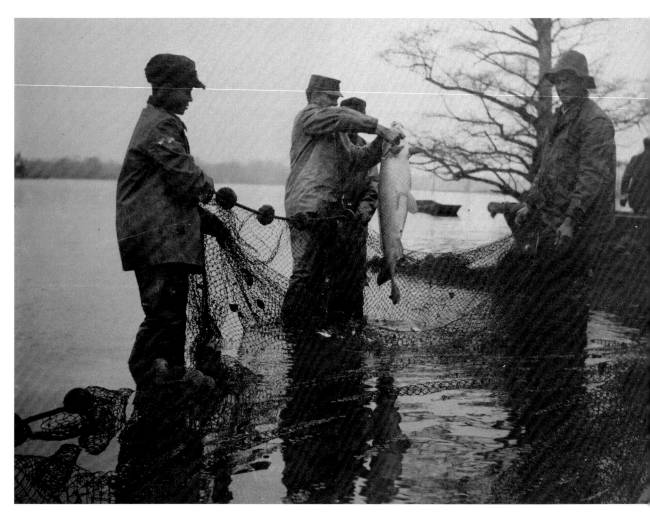

Chickahominy fishermen, 1918. Photo by Frank G. Speck. N12631

what was needed, although reality does not always live up to philosophical alignment, and game such as deer and wild turkey were overhunted at times. Indigenous forestry techniques also encouraged the growth of nutritious nut trees, including the black walnut.

Perhaps the Piscataway's richest resource was the Chesapeake Bay itself, which held immense oyster and crab populations. Oysters grew to thirteen inches long, creating prominent reeflike formations that were a danger to the European boats that came later. Native peoples harvested

and roasted oysters, and heaps of shells can still be found in processing areas such as the high cliffs near the Huckleberry, documenting the countless generations who were sustained by what is now thought to be a delicacy. Shad, sturgeon, and rockfish all populated the bay. North America's largest estuary and an essential haven for migratory birds, the Chesapeake and her environs are an incredibly wealthy trove. But Native peoples did not merely see the land and waters in terms of economics. There was and still is a spiritual gravity to the land, and its rivers were considered to be the very veins of Mother Earth. Inheritors of the ancient chiefdom still accept this as a guiding principle.

Uttapoingassenem had been followed by thirteen generations of *tayacs* by the time the English arrived on the *Ark* and the *Dove* in 1634. Piscataway towns had expanded and networks had increased throughout the bay region long before colonization. Lives were lived and lost. Thousands of ancestors had been buried in ossuaries, or mass graves, so that they would be together in death. After being lovingly laid bare in the old funerary traditions of the Piscataway Chiefdom, their bones were placed directly into the earth, without even flesh covering them. While hundreds of human remains were excavated by anthropologists in the late nineteenth and early twentieth centuries, the vast majority of ancestors are deeply bound to the very soil. The land remembers Uttapoingassenem and his legacy.

THE DECLINE, THE FALL, AND THE RECOVERY

Entire societies shattered under the weight of English colonization, and the Piscataway Chiefdom was no exception. In spite of pandemic diseases, violent upheavals, dislocation, and degrading racial policies, however, there are miraculous survivors. Today, there are still Piscataway people who live near and make pilgrimages to their ancestral lands, the places that still remember them.

When the *Ark* and the *Dove* arrived with the first Catholic colonists,

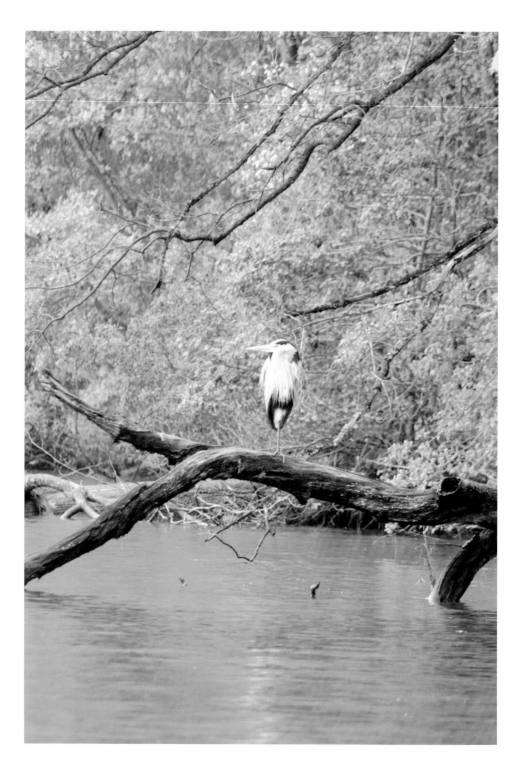

A heron on the
Pamunkey River in
Virginia, 2003.

the colonists' immediate intent was to convert the environment to capital. While it took about a hundred years to completely "solve" the "Indian problem" by removing the Piscataway from their lands, colonists overran reserved lands within the first decades. Another modern ally of these lands, Kent Mountford, has carefully documented centuries of environmental history for the Chesapeake Bay Program. Mountford details how colonists cleared forests for growing food and cash crops like tobacco. Hogs foraged in the forests, destroying the region's diverse indigenous plants. Wetlands were drained. Erosion spun out of control. By the nineteenth century, sediment filled the bay and rivers, creating the waterways' contemporary profile: wide, shallow, and muddy. In the 1800s, about 15 million bushels of oysters were harvested annually and unsustainably. Shad and sturgeon were fished to near extinction. More recently, nutrients from farm fertilizer have caused algae blooms and massive fish kills. Unrestrained urbanization and suburbanization continue to threaten the Chesapeake Bay's ecosystem.

But the land remembers its lush, abundant, indigenous millennia. With help from environmental regulations instituted in the 1970s, there has been some recovery and restoration. Much of the damage might be irrevocable, but, like treatment for a chronic illness, collective efforts may well stop the decline and bring about a measure of restoration.

The Native landscape at the National Museum of the American Indian provides a small glimpse of the rich diversity of the Chesapeake Bay region. On the museum's opening day in September 2004, a bald eagle flew over a procession of more than 20,000 Native delegates and some 60,000 others of all backgrounds — allies now not only in that experience but also in our hope for the future of this place. As we danced on the National Mall together in the shadow of the U.S. Capitol on land that not so long ago was home to generations of Native people, I think the earth recognized our footsteps.

Dedicated to the memory of Calvert Posey (1924–2006), tenacious ally.

ALWAYS BECOMING

NORA NARANJO-MORSE

Digging.
Planting.
Covering.
Nimble fingers pressing seeds into
fertile ground.
Symmetry of motion.
Sewing
 Corn
 Tobacco
 And sweet grass
 Into moist
 Waiting earth
beds.
Fluid
 Purposeful plant life in every
root

opposite: Po Khwee *(Moon Woman) sculpture of the* Always Becoming *series, 2007. Artist Nora Naranjo-Morse (Santa Clara Pueblo) wrote the poem "Always Becoming" in honor of the sculptures' dedication. The five pieces are titled* Ta dah *(Father),* Gia *(Mother),* Hin Chae *(Little One),* Po Khwee *(Moon Woman), and* Ping Tse Deh *(Mountain Bird).*

Trunk and limb
Germinating
In her round
Deliberate belly.
Matriarchal energy beneath our feet
Bringing forth a legion of buds
in innocent
Promising
Glory.

Breathe the old woman
encourages.
It will keep the plants growing.

Breathe in the first song of a new cycle
Sung by female moons.
With harmonies clear
Soothing.
Echoing across Wetlands
Deserts
Mountains
And Seacoasts.
A new beginning with ancestral songs.
Navigating steady and
sure
Across a Celestial canvas with
Prayer bundles in hand
Singing Welcoming chants.
It is the beginning of a simple
Wondrous gift
Life.

Digging.
Pressing.
Wrapping.
Layering.
At the corner of 4th and Independence.
At the cross section of asphalt and
fertile ground.
 Male stars and female moons washed in
 Sonoran light.
Illuminating
 Nan chu Kweejo's clay colored
children
 Rising through the cracks
 And weight of concrete
and steel.
Songs from grandmothers
 Passed on.
Movement
 Steeped in spirits
 Dancing willow like.
Weaving
 With walrus needles
 Air
 And sage
 To make clay skin
people.
Clay skin people who will become Towa
 Who in time will become clouds
 Bringing rain
 Nurturing waiting earth beds.
And so it goes

Gia (*Mother*) (*center*),
Ta dah (*Father*) (*left*),
and Hin Chae (*Little
One*) *sculptures, 2007.*

Continual rebirth.
Digging
 Pressing
 Wrapping
 Layering
 At the corner of
space
 And culture.
At the cross section of asphalt and
fertile ground.
Grandfather
 New and innocent
 Blessing nimble fingers.
Straw and mud
 Sand and water
 pressed into her round
belly.
Coils made of sweat.
We plant an idea made from passion
 Under the stars with
 Mud caked hands
 Covering the color of our
skin.
Under the stars we are all the same.

Wrapping and shaping
Bending and becoming a
 Mountain bird
 A Moon Sister
 Mother

Father
 And Child.
Above the noise
 Flying.

Old Man Rock sits near by
Watching his Children
 Towa-eeh.

We are the children who have come
 From the South.
A:kon Piye
Tepehuan
Yacci
Mayan
Who weave stories
 Of family
 Desire and struggle
 From reed and yucca.
Patterns stitched from top soil
 Cracked and baked in the sun.

We are the children from the North.
P'ing Piye.
Eskimo.
Tlingit.
Cree.
Raven and Ice people who bring water.
Clean.
Clear water.

We are the children from the East.

Thang Piye.

Iroquoian.

Algonquian.

and Siouan.

Speaking forth a single voice in Locust

And Birch Tree chants.

Facing the cardinal directions

Fearlessly.

Unwavering.

Standing.

Eastward

Where darkness recedes

Into the brilliance of a new

day.

Where night mysteries realign

into morning's

Promise.

We are the children from the West.

Tsan Piye.

Pueblo.

Pima.

Dineh.

Desert land

And cedar scent.

Sagebrush and sandstone.

opposite: *The Always Becoming sculptures greet visitors from among the
museum's tall meadow grasses. The artworks are made entirely of organic materials,
intended to erode over time.*

We are the mud builders
 Who make homes from spit and dust.

And so we have arrived
 At the crossroads of asphalt and fertile ground.

Where Old Man Rock watches his children
 Mix dreams and earth
 Under the elm's expansive wings.

Breathe the old woman says
 Sing your father's sweet grass song
 Prayer bundles in hand
 As you become
 New
 Fearless
 And purposeful.

Keep breathing as you become.

LANDSCAPE
THROUGH AN INTERIOR VIEW

KATHLEEN ASH-MILBY

The land, as depicted by contemporary Native artists, is complex space. Rather than creating work that is simply representational or infused with romanticism, many Native artists have chosen to explore the land's various complicated meanings. Their relationship to the land is multilayered, encompassing personal and collective memory, history, and narrative. These artists are not rigidly bound by tradition in their expressions of landscape; instead, their sources of inspiration range from the profound to the mundane, the past to the present, and the deeply personal to the political. The results are inherently indigenous, revealing the complex relationships contemporary Native people have to historical representations of the landscape as well as to the land itself.

When most people envision a depiction of the landscape, they immediately conjure up romantic images of landscape painting. This imagery is indelibly written in the popular imagination. While most of Western art history focuses on the masterworks and revered traditions of the "Old World," such as classical Greek sculpture, Medieval architecture, and portrait and narrative paintings from the Renaissance to the Dutch Golden Age, American art lays claim to the "peak" of landscape painting. The late nineteenth-century works of Albert Bierstadt, Asher Durand, and others who painted the American West in the style of the Hudson River school are widely recognized for mastering the depiction of the landscape. These

Like flesh, landscape is the living and lived surface of a body — the earth's body. It is how earth appears to the gaze and the touch, how it surfaces to view and grasp.
Edward S. Casey,
*Representing Place:
Landscape Painting
and Maps* (2002)

Andy Tsinahjinnie (Navajo, 1916–2000), Deerhunt on Horseback, ca. 1938.
Watercolor on paperboard, 50.6 × 64.9 cm. 22/8649

paintings also became potent tools in defining, inspiring, and justifying western expansion and colonialist policies in North America, which in turn increased their popularity. This body of work reinforced the myth of an empty frontier bestowed upon Euro-American settlers and entrepreneurs for exploitation through Manifest Destiny. The Native presence in the art of this era is most notable for its absence. When they are included, Native people are minor, incidental elements in the scenery, if not proof of the "untouched" wilderness, ripe for the taking.

Within prehistoric and historic Native art traditions, there is no evidence of the practice of creating illusionary depictions of the land. Throughout most of the twentieth century, Native American representational art was dominated by what was once defined as a traditional style of painting, based on the conventions of Plains ledger drawings and Pueblo Kiva murals. With roots in Dorothy Dunn's classroom at the Santa Fe Indian school in the 1930s and with the influence of several seminal painters working in Oklahoma and the northern pueblos of New Mexico in the early twentieth century, this "studio" style of painting is defined, in part, by its very lack — or minimalist use — of landscape. Later in the century, Native art in nontraditional media and forms experienced a florescence, resulting in a wide range of work in painting, sculpture, mixed media, photography, and new media.

Within this large body of work, many artists have used the land as their inspiration and subject. Anishinaabe (Ojibwe) artist George Morrison (1919–2000), for example, spent the greater part of his career portraying Lake Superior as a series of abstractions of color and light, united by the interminable presence of the horizon line. Morrison's work is featured on the cover of the catalog for *Our Land, Ourselves* (1990), a seminal exhibition at the State University of New York at Albany that demonstrated that, while European landscape conventions were still rare, representation of the land had clearly become a significant subject in contemporary Native art. The title of the exhibition underscores the intimacy and fluidity of the relationship between Native people and the land, since, as curator Jaune Quick-to-See Smith (Salish/French-Cree/Shoshone) made clear, the artist's work, in all its iterations, is created "in and through an interior view."

Within the National Museum of the American Indian's collection of contemporary art, works by many different artists reveal this complexity. Alan Michelson (Mohawk, b. 1953), for example, addresses the relationships between place, memory, and our national "historical amnesia" throughout his body of work, including the multimedia installation *Mes-*

George Morrison (Grand Portage Band of Chippewa, 1919–2000), Untitled (Horizon), 1987. Lithograph (23/30), 66 × 182.9 cm. 25/9064

pat (2002), which examines these phenomena in present-day Queens, New York. The area once known as Mespat is now an industrial site located on Newtown Creek, which bisects the boroughs of Queens and Brooklyn. The creek is heir to a long history of environmental abuse and pollution, but throughout the seventeenth century a network of Native communities lined its banks and fished its waters. Michelson revisits this locale, projecting images of the current landscape, purged of Native presence, onto a large screen composed unexpectedly of turkey feathers. This material refers both to the indelible indigenousness in the land and the now-forgotten use of feathers fashioned into cloaks that was once observed among Native people of the Northeast by early European explorers. It is likely that the current residents of Maspeth, Queens, many of whom are first-generation immigrants, are oblivious to the rich Native history that lies beneath their feet.

James Lavadour (Walla Walla, b. 1951) has also deconstructed the landscape of his home on the Umatilla Indian Reservation in numerous paintings throughout his prolific career. While his earlier work conforms closely with Western landscape painting traditions, his recent expressions

Alan Michelson (Mohawk, b. 1953), Mespat, *2001. Digital video with sound, turkey feathers, mono-filament, 426.7 × 335.3 cm. 26/5774*

James Lavadour (Walla Walla, b. 1951), Blanket, 2005. Oil on board, 183 × 396 cm. 26/6079

are less literal and more imaginative. *Blanket* (2005), shown quite fittingly in the 2007 exhibition *Off the Map* at NMAI's George Gustav Heye Center, is an example of this uninhibited and multifaceted approach. The fifteen-panel work provides multiple perspectives of the land: long-range vistas with clearly defined horizons contrast with highly abstract constructions; cool and serene screens of color are juxtaposed with fiery and tumultuous terrains. Together they reveal a tangible intimacy and profound understanding of the earth as a living and dynamic force.

The work of Navajo artist Emmi Whitehorse (b. 1956) reveals a different character within the land. Deeply infused with light and sensation, her dreamy and highly nuanced compositions reflect her memory and ongoing experiences with the desert landscapes of Arizona and New Mexico. Although she incorporated recognizable elements from the land such as seedpods, twigs, and leaves in earlier work, in recent years, she has reduced these elements to less tangible symbols and forms. For example, in

Emmi Whitehorse (Navajo, b. 1956), Standing Water, 2002.
Mixed media on paper, canvas, 130 × 100 cm. 26/5557

Marie Watt (Seneca, b. 1967), In the Garden (Corn, Beans, Squash), *2003.*
Wool, satin binding, silk thread, 274.3 × 223.5 cm. 26/5807

Standing Water (2002), she creates an ambiguous environment that suggests a murky pool of water where organisms float and multiply. Across this chasm of light and color, Whitehorse inscribes scratches, lines, and amorphous shapes that drift across the surface of her canvas.

Marie Watt (Seneca, b. 1967) is another artist whose abstract work draws from an indigenous understanding of the land. Her mixed-media textile work *In the Garden (Corn, Beans, Squash)* (2003), made from reclaimed wool blankets, is full of references to creation, regeneration, and nature. Careful observers will locate the three light-green diamond shapes representing corn, beans, and squash — staple crops of the Haudenosaunee (Iroquois) and other northeastern tribes. Known as the Three Sisters, these plants enhance each other's growth when they are cultivated together. This ingenious practice of indigenous horticulture also provides an apt metaphor for Native philosophies about familial and environmental interdependence.

As Native art demonstrates, the traditional understanding of the land is far more nuanced and multidimensional than can be expressed through simple representation. The originality and freedom of artists like Morrison, Michelson, Lavadour, Whitehorse, and Watt locate their work outside the boundaries of European landscape traditions and challenge our expectations of contemporary Native artistic expression. For Native people, the relationship between the self and the land, as well as the artist and the landscape, will always be inseparable from the weight of history and belief. It is the ability of contemporary Native artists to delve below the surface to wrestle with these relationships and contradictions that gives us all a deeper understanding and appreciation of the meaning of the land. In its diversity and eloquence, Native art helps us to understand the natural world and our place within it.

This essay was adapted from "The Imaginary Landscape," in *Off the Map: Landscape in the Native Imagination*, edited by Kathleen Ash-Milby (Washington, D.C.: National Museum of the American Indian, Smithsonian Institution, 2007).

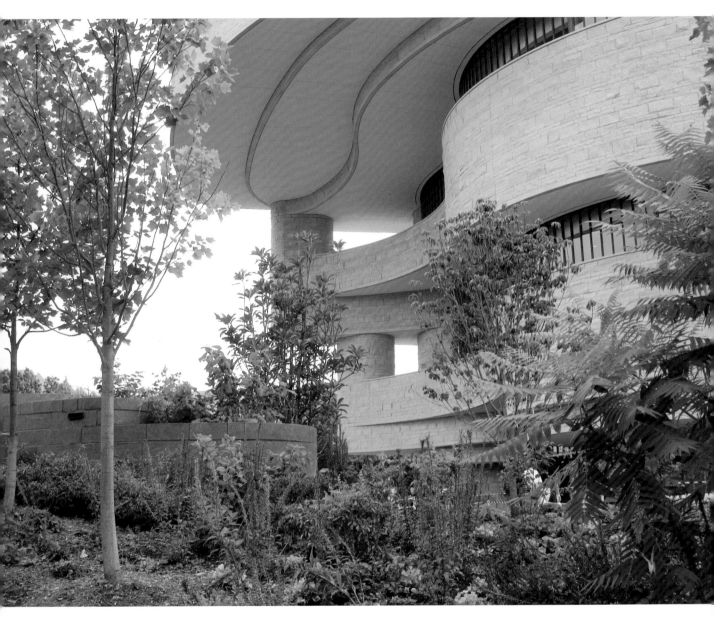

Tuliptree, southern magnolia, and dogwood trees provide shade for sumac and cardinal flower in NMAI's woodlands.

STORIES OF SEEDS AND SOIL

GABRIELLE TAYAC *&* TANYA THRASHER

Every plant, animal, and stone has a story to tell. This concept can be understood through the more than 27,000 trees, shrubs, and herbaceous plants; 40 massive boulders; and 4 Cardinal Direction Marker stones placed throughout the National Museum of the American Indian's landscape. All were carefully selected, blessed with prayer and song, transported over thousands of miles, and thoughtfully re-oriented on the museum's four-acre site. These living beings traveled by boat, helicopter, flatbed truck, and tractor-trailer, and when they arrived at the museum, they were tearfully and joyfully welcomed as long-absent relatives.

Four hundred years ago, the Chesapeake Bay region abounded in forests, meadows, wetlands, and Algonquian peoples' croplands. This land, as all of the Americas, can be further understood through indigenous peoples' cultural perspectives. Over millennia, intense observation and practical experience formed deep knowledge of place. The specific indigenous people of the area now known as Washington, D.C., were called the Anacostans, a tribe belonging to the Algonquian-speaking Piscataway Chiefdom and for whom the Anacostia River is named. The Anacostans did not survive as a distinct people past the first 100 years of English colonization; however, related Algonquian peoples — including the Nanticoke, Piscataway, and Powhatan — maintain a distinct relationship with

All seeds have stories. The evolution of stories, knowledge, and memories of our ancestors are embedded in them. We take care of them like they took care of us. . . . We prepare them for their journey.

Donna House (Diné/ Oneida), 2004

In the language of the Algonquian peoples who once lived on this land, wingapo, or "welcome." Welcome to a Native place.

Entering the museum grounds, visitors immediately encounter the indigenous plants and voices that existed here 400 years ago. The sounds of the city soon fade, replaced by the cacophony of nature: water crashing onto boulders and flowing along the forest's edge; ducks and birds nesting among the wetlands reeds; and the rustling of tall grasses in the meadow.

This site plan shows the four environments that encircle the museum and a few of the many exterior design features that represent Native peoples' connection to the land and respect for the Four Directions. The following plant-based information is a synthesis of ideas based on generations of traditional knowledge and practice; under no circumstances should it be considered a guide to the use of herbal medicine.

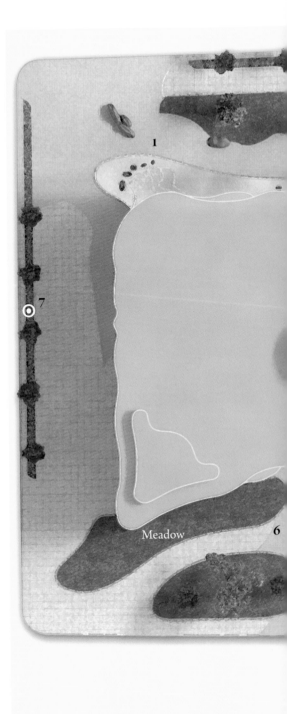

KEY

1. The northwest entrance features the Grandfather Rocks, birch trees, and a cascading waterfall.
2. Northern Cardinal Direction Marker
3. The museum's offering area is a place for quiet reflection.
4. Eastern Cardinal Direction Marker
5. Southern Cardinal Direction Marker
6. The south entrance features a spiral moon pattern in the pavement.
7. Western Cardinal Direction Marker

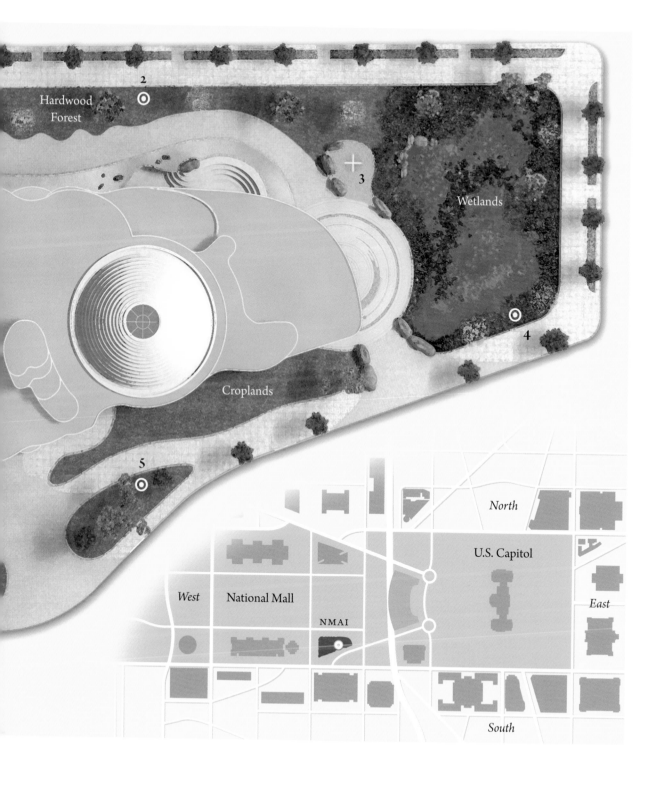

Hardwood
Forest

2

3

Wetlands

4

Croplands

5

North

U.S. Capitol

West National Mall

NMAI

East

South

Incan woven manta, Bolivia, 16th c. 5/3773

the land to this day. These peoples gained a deep understanding of the land through observation of the natural world.

Although the museum's diverse plantings specifically recall the indigenous environment and culture of the Algonquian peoples prior to European contact, the four environments are presented with sensitivity to the enduring connections that Native peoples throughout the Americas have to their homelands. Native peoples do not merely adapt to a natural environment but traditionally manage their ecosystem in a way that is consistent with their philosophical worldviews. For example, Native peoples encouraged the growth of a variety of plants in the same area, a technique known as biodiversity. Biodiversity is just one concept that was used to restore the museum grounds to their ancestral form.

The Diné (Navajo) people of the Southwest articulate an idea that profoundly informs NMAI's landscape and architecture. In the Diné language, *hózhó* means the restoration of beauty and harmony, which was a guiding principle of Donna House's landscape-design work at the museum. Rigorous botanical research and numerous consultations with Native peoples went into the effort to bring back the Algonquian environment.

The towering glass doors at the museum's main entrance — etched with sun symbols — face the east and greet the rising sun, as do many traditional Native homes. Most Native peoples follow a solar calendar, which indicates the proper time to hunt, plant, harvest, and conduct ceremonies. The changing seasons have long been interpreted and honored as a sacred cycle of life, and keen observation of these cycles, especially the solstices and equinoxes, has been considered necessary to ensure the seasons' continuation.

Through strict observation of nature, Native peoples learned the concept of duality or the balance between two equal states. The duality of nature is reflected throughout the museum grounds, for example in images of the sun and moon at the museum's main entrances and in male and female plants in each environment. In concert with this concept, most

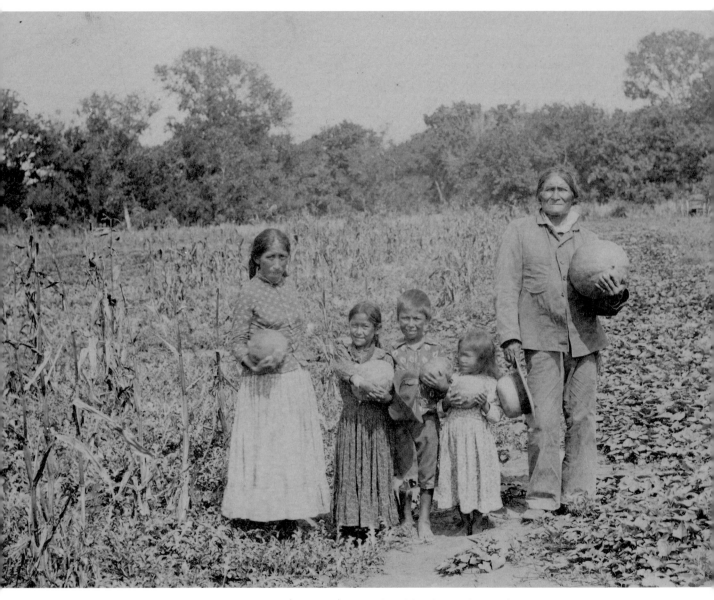

Goyathlay (Geronimo) with wife and family in melon patch,
Fort Sill, Oklahoma, ca. 1895. N37517

Native societies believe that living on the land involves reciprocity — a process of give-and-take. Humans are generally considered to be responsible stewards of land rather than owners. The Kanaka Maoli (Native Hawaiians) express this idea through the philosophy of *aloha ʻaina* or "love of the land." Similar to many other Native peoples following ancestral principles, the Kanaka Maoli judge the merit of their actions by whether or not they show proper respect for their environment and compassion for the land.

Many Native peoples have developed philosophies about the connections between all entities in the universe. Humans are not generally believed to dominate the world in most traditional Native teaching but instead are related to all other beings. The Lakota, for example, affirm their prayers with a phrase that shows their understanding of this idea: *mitakuye oyasin*, meaning "all my relations." In many Native languages, non-human beings — either living or inanimate — are referred to in kinship terms. These ideas come from the sacred oral narratives passed on from one generation to the next.

Upland Hardwood Forest

The grouping of trees, plants, and shrubs on the museum's north side is known as an upland hardwood forest. The more than thirty species of trees reflect the dense forests that exist in the Blue Ridge Mountains, along the Potomac River, and elsewhere. Before European contact, Virginia and Maryland were heavily forested with birch, alder, red maple, beech, oak, witchhazel, and staghorn sumac, among others.

The Nanticoke and other communities relied upon the forest for a variety of foods and medicines, including the willow tree, which was used to create aspirin. Now the most widely used drug in the world, aspirin was made from the tree's inner bark, which Native peoples boiled or powdered.

The hardwood forest spans the museum's north side.

Eastern Redcedar

Eastern redcedar is connected to the spiritual traditions of many Native communities, including the Kiowa and Lenape (Delaware). The tree's unique red, aromatic heartwood and evergreen leaves are valued for ceremonial and medicinal uses. Native peoples make flutes and other items from the beautiful wood, and they burn the tree's leaves, inhaling the smoke to both purify themselves and help cure head colds.

Native peoples discovered such medicines in many ways, including the observation of animals. For example, they saw that bears rubbed certain plants on their fur, and they learned how to use such plants to treat a variety of human illnesses.

This lush environment is comprised of three distinct types of forest plantings. The three plant communities all require different levels of moisture, ranging from xeric (dry) to mesic (moderate) to hydric (abundant).

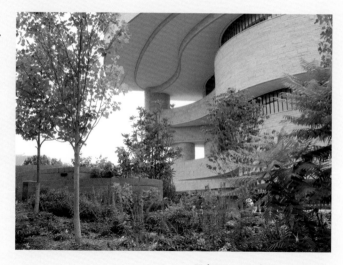

Tuliptree, southern magnolia, and dogwood trees provide shade for sumac and cardinal flower in NMAI's woodlands.

Witchhazel

A popular commercial remedy and facial astringent throughout the world today, witchhazel was first harvested by Native peoples in the eastern United States. The Mohawk, Menominee, Potawatomi, and Mahican tribes used witchhazel as a sedative and as an astringent and valued its ability to stop bleeding. They also used witchhazel to treat skin irritations, burns, and insect bites and made a tea with it, often mixed with maple syrup, to treat sore throats.

Strawberry

A member of the rose family, the strawberry is an excellent source of anti-oxidants and the only fruit with seeds on the outside rather than the inside. Many tribes, including the Haudenosaunee (Iroquois) and Wampanoag, crush the berries to make a refreshing drink and mix them with cornmeal to make strawberry bread. Native peoples greatly value the sweet fruit and have many stories of how it came to be. The Cherokee relate the following story about the creation of the strawberry: "Long ago, Man and Woman lived together and were very happy. Yet one day, the couple argued, and Woman left in haste. Taking pity on the husband, the Sun placed raspberries, blueberries, and blackberries in her path, in an attempt to stop her. Only the Sun's final gift of strawberries was sweet enough to ease the woman's anger and reunite the couple."

Strawberry basket, ca. 1985. Made by Mary Adams (Akwesasne Mohawk, b. 1917). 26/3867

Sassafras

Known as *pakwani-misi* to my people, the Shawnee, the sassafras tree is a significant, living link to our community history. Relocated to Oklahoma Territory in the 1800s from their original lands in the Ohio Valley and West Virginia, our ancestors were forced to leave their villages and familiar food sources. Traditional ways were compromised, but several Shawnee groups maintained traditional practices, including the harvesting of sassafras. This beautiful and distinctive tree, which also happened to grow in the new northeast Oklahoma environment, became an important tie to our original homelands, ancestors, and way of life.

Before the relocation, the Shawnee and other tribes taught settlers how to harvest and use sassafras, and demand grew quickly. In the 1700s, it became one of the largest exports to England, second only to tobacco. Once it gained popularity, sassafras was sold commercially as a flavoring in tea and as one of the first soft drinks — root beer.

For centuries, Native peoples used the bark, roots, and leaves of the sassafras tree as medicine and flavoring in food and beverages. The Delaware, Nanticoke, and Seminole, among many other tribes, used sassafras as a blood purifier, a poultice for bee stings, and an eyewash. The Choctaw of Louisiana and Mississippi taught settlers to dry the leaves and grind them into a powder, now known as "filé," a pungent flavoring for soups and gumbos.

All three Shawnee groups (Eastern, Absentee, and Shawnee) continue to harvest sassafras today, drinking tea made from the root bark to remove impurities from the blood. I was taught to gather the roots and bark of the sassafras when the sap runs down the tree (in the fall or winter), when the root bark below the ground is the strongest. When taken in the spring, the tea from the root bark helps thin the blood for warmer weather, and in the winter, the tea strengthens it to protect against the cold season. My great uncle, Jasper Milhollin, used to drink sassafras tea to help with

Shawnee bandolier bag with sassafras leaf design, ca. 1830. 10/3133

Vivian Gokey (Eastern Shawnee) gathering sassafras in Oklahoma, 2004. Photo courtesy Cathleen Osborne-Gowey (Eastern Shawnee).

migraine headaches. I have also learned to harvest the plant in the proper Shawnee way: never removing the smallest or largest plant, asking permission, and leaving an offering (such as a coin or special rock) to the plant's spirit. Like the Cherokee teachings, the Shawnee believe that you must pass over four families of the plant you seek and only gather from the fifth, ensuring that it will continue to flourish for future generations.

— RENÉE GOKEY

Wetlands

The museum's diverse wetlands area — and the ducks, squirrels, and dragonflies that make it their home — represent the original Chesapeake Bay environment prior to European settlement. Native communities of this region harvested the roots of cattails and yellow marsh marigolds for food during the winter and early spring, when root vegetables and paw-paw fruit were scarce. Cypress trees were prized for their usefulness in making dugout canoes. River birch, swamp milkweed, pond lilies, silky willow, and wild rice abounded in the dense marshes, as they do in the museum's natural habitat.

Native peoples of the Chesapeake made full use of resources in the wetlands, without draining or exploiting the waterways. Reeds were woven into mats and made into cordage for nets. Massive oyster beds grew in the river, and oysters were roasted to provide food throughout the seasons. While severely decimated during the nineteenth and twen-

River birch bark.

The museum's east entrance faces the wetlands.

Cattails and cardinal flower in NMAI's wetlands.

tieth centuries by overfishing, pollution, and erosion, the bay is making some recovery due to human efforts to restore a natural balance to this rich ecosystem.

Swamp milkweed.

Southern Bald Cypress

In the middle of the museum's wetlands, you can see the entire life cycle of the unusual and long-living southern bald cypress tree. A fallen trunk was placed in the wetlands to evoke an authentic wetlands environment, and a young cypress has begun to grow out of the stump of the fallen tree. The Choctaw used the tree's bark to make cordage, or thick ropes, and communities such as the Piscataway favored the cypress for canoe and paddle making.

Swamp Milkweed

Distinguished by its scarlet, hourglass-shaped flowers and white sap, the swamp milkweed is a beautiful wetlands plant harvested by Native tribes. The Menominee gathered the plant "heads" when in full bloom and added them to soup or stored them for winter use. The Sac and Fox used swamp milkweed root in a strengthening bath, and they made twine, fishnets, and straps from the plant's fibers.

Broadleaf Cattail

One of the most well-known wetlands plants, the cattail contains ten times the amount of starch as potatoes — an important source of energy. In addition to using the plant for food, Native peoples used its "fluff" to insulate footwear or bedding, as well as to pad a baby's cradleboard. The Mi'kmaq, Paiute, and Ho Chunk, among many other tribes, used twisted strands of cattail leaves to make thick cordage that was then woven into strong, weatherproof mats for house or floor coverings or fashioned into toys, dolls, and duck decoys.

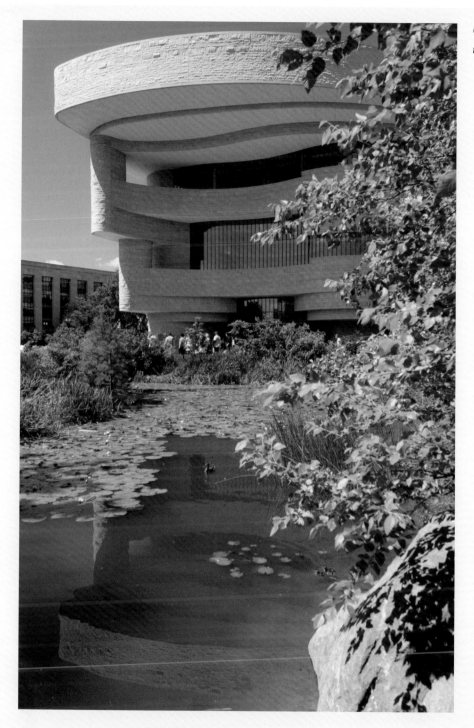

Cypress tree and water lilies in NMAI's wetlands.

Wild Rice

According to the oral tradition of the Anishinaabe (Ojibwe), wild rice is an important part of the community's origin story and continues to be a central element in ceremonies and feasts. Known as *manoomin*, wild rice is a sacred food given to the Anishinaabe after a great migration long ago. Following a prophecy that instructed the people to move west until they reached a place "where food grew on water," the Anishinaabe migrated from their original homelands along the East Coast. Discovering *manoomin* growing on the water in the Great Lakes, the people knew they had reached their new home.

A grass that grows eight to twelve feet tall in swiftly moving water, wild rice is harvested in the Great Lakes region during the month of September, known by the Anishinaabe as Manoominike Giizis or the Wild Rice Moon. In tribal communities, including those in Louisiana and South Carolina, wild rice is harvested traditionally, following strict protocols. Two people harvest the grains together, one using a long pole to direct the canoe or boat and the other using two smooth sticks, or "knockers," to bend the sheaths of rice over the canoe and gently knock the ripe grains from the top of the plant. Not all of the rice ripens at the same time, so several trips are required during the harvesting season. Some of the ripe grains fall into the water or are left to reseed, ensuring a continued crop the following year.

After harvesting, the rice is sun-dried and parched in large kettles to loosen the hull of the grain. To fully separate the delicate grain from the hull, a process known as "jigging," the rice is placed in a bucket or skin-lined pit, in which a "jigger" walks about in soft-soled moccasins. The loosened hulls and grains are placed in a birch bark winnowing tray and gently tossed, so that the heavy rice falls to the bottom and the papery hulls blow away. Rice is stored in baskets, bags, or birch bark containers known as *makuks*.

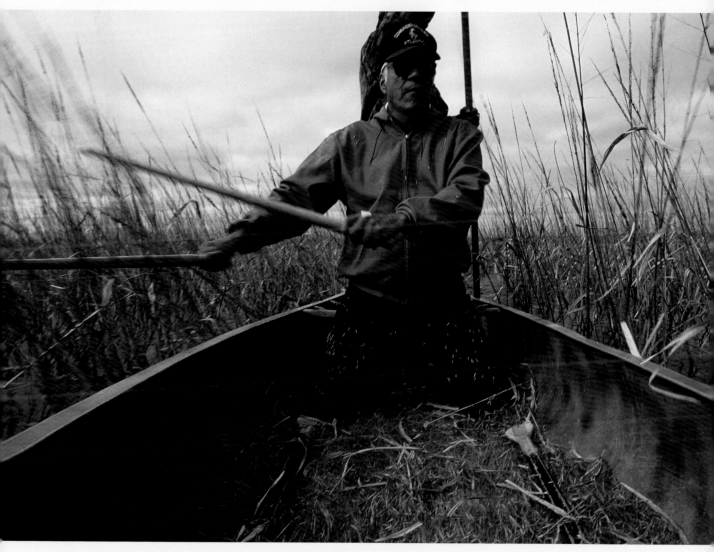

Using traditional harvesting techniques of their Anishinaabe (Ojibwe) community, Gene Goodsky (seated) and Frank Porter gather wild rice on Nett Lake in Minnesota, 1994.

Low in fat and high in fiber, protein, and carbohydrates, traditionally harvested wild rice is a popular and healthy food, with a smoky flavor and a rich, gray-brown color.

—JOSÉ MONTAÑO

Traditional Croplands

Agricultural Gifts to the World

About 60 percent of the world's diet today is derived from foods indigenous to the Americas, such as potatoes, chilies, tomatoes, and even chocolate. The museum's traditional croplands incorporate the irrigation and planting techniques of Native peoples that revolutionized agriculture around the world. Expert farmers, Native peoples encouraged the growth of many plants together, which promoted healthier crops and resulted in a greater variety of medicinal plants.

Long before 1492, Native peoples across the Americas had cultivated more than 300 food crops, and farming was an integral part of their lives. Native farmers practiced a variety of planting techniques, including crop rotation, which helped to rest and restore the soil to protect topsoil from erosion and to help conserve moisture. Ancient Puebloan peoples allowed edible weeds such as amaranth and mustards to grow wild among their crops, and today, the Hopi encourage weed growth around corn plants to prevent wind erosion.

During the winter months, the museum's croplands include a waffle garden, a traditional dry-farming method developed by the A:shiwi (Zuni) peoples of New Mexico. From above, these small garden plots

The croplands area follows the curves of the south façade.

View of Zuni "waffle" gardens, Zuni Pueblo, New Mexico, 1919.
P11433

Wintertime waffle garden in NMAI's croplands.

look like waffles, with recessed squares of soil that retain moisture. Waffle gardening makes optimal use of limited water resources in a semi-arid environment.

The Three Sisters

Known by many tribes as the "Three Sisters" or *tres hermanas*, corn, beans, and squash are planted together in a way to enhance each other's growth and to replenish the soil — an ingenious technique called companion planting. The tall stalks of corn provide a natural trellis for the beans; the beans take nitrogen from the air and put it into the soil, feeding the corn, bean, and squash plants; and the squash plant's large, low-lying leaves protect the roots and soil. When eaten together, they provide a fairly complete diet — corn has carbohydrates and amino acids, beans have protein, and squash has vitamin A.

Native American Astronomy

Indigenous societies have engaged in celestial study for a long time. The ancient Mayan pyramid, Chichén Itzá, is aligned on the summer solstice to capture light in the form of a serpent. A more contemporary example can be found among Native Hawaiians, who have revived an ancestral technique of noninstrumental navigation using stars and horizon lines on transoceanic journeys. The alignment and architectural design of NMAI pay respect to this continuous knowledge building with the universe.

The pattern embedded into the paving stones of NMAI's Welcome Plaza represents five planets — Mercury, Venus, Mars, Jupiter, and Saturn — the sun, and the moon in their positions at sunset on the museum's birthdate, November 28, 1989. Polaris, the North Star, sits at the center of the plaza. The paths of the planets across the sky on this date begin on the eastern side of the plaza and follow an arc to the west, marking the points of rising and setting.

Native peoples across the Western Hemisphere rely upon ancestral

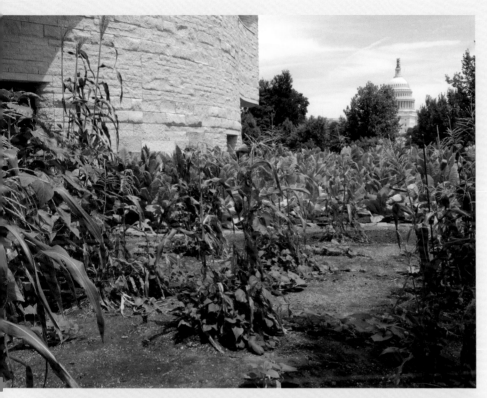

The "Three Sisters" plants flourish in NMAI's croplands. A popular museum event for all ages, the release of ladybugs throughout the summer provides a natural form of pest control.

Sac and Fox tomahawk pipe with celestial designs, late 19th c. 2/5306

top: *The museum grows a variety of indigenous species of corn, including Cherokee White Eagle and Black Mexican.*

right: *Couple making cornhusk mats, Onondaga, New York, ca. 1894. N15289*

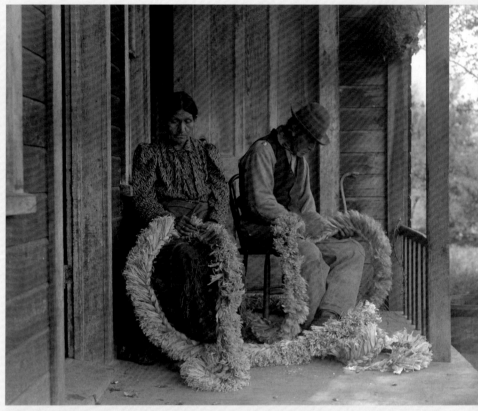

knowledge of the moon to organize traditional ways of life, including agricultural and ceremonial cycles. Algonquian peoples in the Chesapeake region observe thirteen lunar cycles, each with its own characteristics. The Algonquian-speaking Powhatan, for example, traditionally refer to the time around May as the "Corn Planting Moon." Monthly phases of the moon also serve as important time-keeping devices for gatherings. The Powhatan once kept time by noting lunar cycles on notched sticks or knotted strings.

Corn

In many Native American languages, the word "corn" means "our mother" or "our life." The creation stories of the Q'eqchi Maya community and Santa Clara Pueblo, among many other tribes, celebrate corn as the sustainer of life.

The Diné (Navajo) tell the story of First Man and First Woman, who were produced from two ears of corn.

Native people have grown and traded corn for more than 10,000 years, developing over 250 varieties and linking communities across the Americas. Also known as maize, corn originated in the Tehuacan Valley of present-day Mexico, where Native peoples cultivated the seeds of a wild grass (*teosinte*). Ancient corn had husks covering each kernel. Over time, Native peoples learned to grow the many species of the plant that we know today, with more kernels per cob and a single husk.

Domesticated sunflower.

Squash

The word "squash" comes from a Narragansett word, *askutasquash*, meaning "green thing that is eaten raw." The origins of the squash plant in the Americas can be traced to the southern region of present-day Oaxaca, Mexico, where seeds have been found dating back to 7849 B.C. From Peru to the eastern woodlands of America, Native farmers cultivated various types of squash, including acorn squash, butternut squash, Hubbard squash, and pumpkins.

Native people value squash, rich in vitamin A, as an important part of their diet. Squash is dried, boiled, baked, and eaten raw; the flowers, shoots, leaves, and seeds of the plant are used as well. The Hopi tribe of Arizona considers the squash blossom a symbol of fertility and incorporates it as a design in jewelry.

Sunflower

True to its name, the sunflower follows the track of the sun across the sky. This phenomenon is due to the differing growth of the stem — the shaded side of the plant grows faster than the sunlit side, thereby causing the stem to bend toward the sun. First cultivated by Native peoples in the Southwest nearly 3,000 years ago, the sunflower has become one of the most well-known and highly prized plants in the world.

The Haudenosaunee (Iroquois) and Diné (Navajo) communities, among many others, ate the seeds, extracted the oil from the seeds for hair tonic, and used the seeds, petals, pollen, and stalks for dyes, clothing, and flute making.

Tobacco

According to Potawatomi oral tradition, a long time ago a young man lived with his sister in a wigwam near a lake. One night the brother received instructions in a dream, which he relayed to his sister: "Five young men will knock on the door — ignore the first four, but speak, laugh, and look at the fifth." It happened just as the brother said. The sister ignored the first four men but opened the door and talked, laughed, and looked at the fifth man. He became her husband. The first four men died of grief, and the new husband buried them.

From their graves grew *nInse'ma* (tobacco), *wapkonen* (pumpkin), *koje'suk* (beans), and *ashktamo* (watermelon). The bridegroom was *ndamen* (corn), and from his union with the woman, all Indian people are descended.

This story is one of thousands passed down through the generations explaining the origins of sacred plants. Tobacco, considered one of the most sacred by Native communities, has many associated origin stories. According to the timelines of Western science, Native peoples of the Peruvian Andes first learned to cultivate tobacco between 5,000 and 7,000 years ago.

By the time Christopher Columbus and his astonished crew witnessed the Taino peoples of the Caribbean islands inhaling smoke from large rolls of burning leaves — called *tabacu'* by the Arawak-speaking community — the plant had been cultivated or traded throughout the Americas for centuries. As the Taino believed, tobacco was a sacred plant used ritually in ceremonies and for healing.

Traditional use of tobacco involves offering the plant itself or its smoke, which rises and carries prayers to the Creator and the spirit world. Occasionally, tobacco is mixed with sumac or other aromatic leaves. Preparation and use can take many forms: tobacco leaves can be smoked; chewed; dried, powdered, and then ingested through the nostrils; steeped in hot water and drunk; rolled into cigars; or wrapped in cornhusks for storing.

Often, tobacco is placed in medicine bundles, given as gifts, or buried with the dead.

Medicinally, tobacco is sometimes used as a mild analgesic with antiseptic properties. Native communities made a poultice from the crushed leaves used to cure earaches, snakebites, and toothaches. Tobacco is still used by Native peoples throughout the Americas in prayer to offer protection. Miners in South America leave offerings of tobacco to the *huari* (deity) of the mines to prevent danger, and Native men and women in the military often carry tobacco or smoke it during ceremonies before departing for service.

Pipes and tobacco pouches are often elaborately decorated to show reverence for the plant. Ceremonial use of tobacco requires following prescribed rituals — for example, the pipe is often offered to the Four Directions and the sky and earth before a breath is drawn. For many people, the pipe is never stored with the bowl connected to the stem, as the two pieces should only be connected when used in ceremonies.

Although there are dozens of species of tobacco plants, Native peoples use primarily two domesticated species: *Nicotiana rustica* and *Nicotiana tabacum*. The latter species was the first to be exported from the Americas and made into a commercial product. Tobacco reached Portugal in 1558 when a member of Columbus's crew, Rodrigo de Jerez, brought a supply home with him. Perhaps because smoke was associated with the devil at that time, he was imprisoned for public smoking. By 1600, tobacco was grown and used widely throughout Europe, and in the following century, the plant was cultivated in China, Turkey, and the Mid-Atlantic and southern regions of the United States.

Tobacco is known by many names: for the Aymara peoples of South America, it is *sayri*; the Mexican Zapotec peoples, *picietl*; and the Zuni of the American Southwest, *ana*. For all Native peoples, however, tobacco is a gift from the Creator given long ago, intended for protection, peace, and healing.

—JOSÉ MONTAÑO

Tobacco "ties" made from dried NMAI croplands plants.

Meadow

The museum's meadow environment consists of abundant grasses, wildflowers, and shrubs, including buttercups, fall panic grass, and black-eyed Susan. The plants are perennials, growing or lying dormant according to the season.

Plants such as sumac, juniper, goldenrod, and wild onion grow thick in sweeping meadow expanses between forested areas. In natural habitats, these open areas provide grazing for deer, once a major source of meat and clothing for Native peoples in the Chesapeake region. According to the Patawomeke people's creation story, the hairs of a deer became humans.

Meadow plants, such as sunflowers, also provided a plentiful food source for tribes across the Americas. The Hidatsa, who still live on the plains of North Dakota, cultivated several varieties of sunflowers, drying the seeds for grinding into a paste, adding the seeds to flour to form

Wild sunflower with ladybugs.

cakes, and eating the seeds whole as a fiber-rich snack. The sunflowers in the museum's meadow habitat are wild (with short stalks, thin leaves, and small flowers), while those in the croplands habitat are domesticated (with tall stalks and a single, large flower).

Plant Medicines

Meadows are important sources of medicinal plants used by traditional healers, who give thanks for the plants through offerings of tobacco, song, and prayer. Plants are considered by some tribes to be the hairs of Mother Earth, and one must express appreciation when taking them from the soil.

No matter where they lived, in meadows or mountains, Native peoples developed medicines from a variety of plants and trees and introduced these natural treatments to the world. Modern pharmacology began when quinine was brought from Peru to Europe in the 1600s to treat malaria. Named for the Quechua word for cinchona tree bark (*quina*), qui-

The meadow begins on the south side of the museum and continues around the western façade.

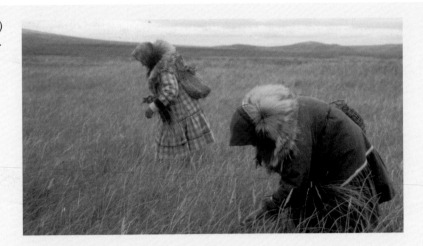

Mrs. Kanrilak (Yup'ik) (left) and a friend gather saltwater grass to make coiled baskets, Tunuak, Alaska. P26512

nine was long used by the Native peoples of Peru to kill the parasites that caused malaria and other illnesses.

Little Bluestem

A hardy perennial grass that blooms during the fall, the little bluestem grows in large bunches across North American meadowlands. The Comanche used the ashes of burned plant stems for treating sores and collected bundles of bluestem for use in sweat-lodge ceremonies.

Black-eyed Susan

Like its name suggests, the black-eyed Susan features a striking black "eye" surrounded by eight to twenty-one bright yellow petals. The state flower of Maryland, this meadow plant is one of the most common American wildflowers. The Seminole, Cherokee, and Anishinaabe (Ojibwe) gathered black-eyed Susan for use as a cold and fever remedy and as a wash for inflammations and snakebites.

Smooth Sumac

The smooth sumac, with its yellow flowers and dark red fruit, was sought by many Native tribes for use as food, medicine, and raw material for baskets and dye. Native peoples boiled the fruit of the smooth sumac to make a refreshing drink similar to lemonade, and the Kootenai drank the juice from the roots to ease sore throats.

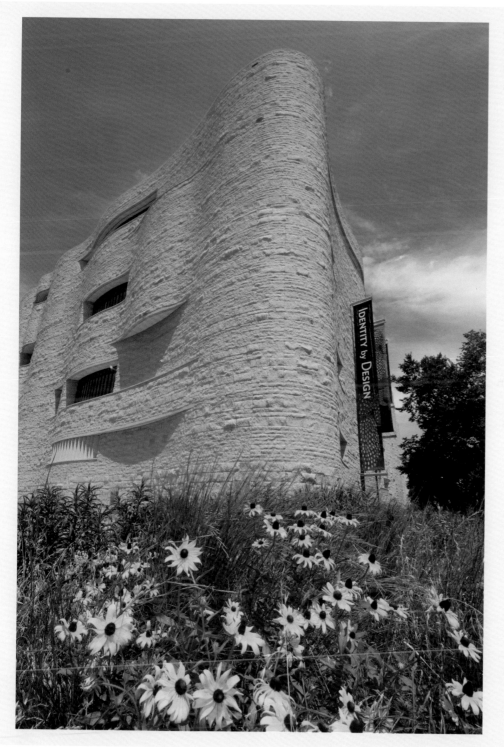

IDENTITY by DESIGN

Understanding Our Place in Nature

Everything is connected — the sun, moon, stars, Mother Earth, wind, fire, rocks, plants, animals, and humans. You cannot separate one from the other. All work together in balance and harmony: this is the foundation of our traditional ceremonies, songs, and prayers.

You cannot simply talk about the plants alone. How can you ignore the earth and sun, which provide nourishment? The animals and insects that exchange the plant's pollen? The powerful medicine held within a root, stalk, or leaf? The seasonal cycles that affect the plant's growth, when it blooms or bears fruit? Plants are part of our universe, given to us by the Creator to ensure our harmony and survival.

Native people use plants for food, clothing, tools, equipment, medicine, transportation, and shelter and, in doing so, honor this interconnected universe. Many of the objects at the National Museum of the American Indian, for example, have been blessed during harvesting of the materials, during construction, or when used by the community.

Each plant is either male or female, with specific uses. A living being, a plant has much to teach us, and that is why we make sure to give an offering (usually corn pollen, tobacco, a song, and a prayer) before separating it from the earth. When a plant is chosen, we are taught to replace it so that it can provide for the following season.

Depending on the use of a plant, seasonal cycles are important because the strength of a plant's medicine changes throughout the year. Many community members know plants well, but only a few are called upon to be medicinal herbalists. These specialists spend a lifetime learning about plants and creating a personal relationship with each one. As Standing Rock Sioux scholar and theologian Vine Deloria Jr. once said, "In this universe, all activities, events, and entities are related. . . . To Indians, life is not a predatory jungle, 'red in tooth and claw,' as Western ideology likes to pretend, but a symphony of mutual respect in which each player has a specific part to play. . . . Because we humans arrived last in this world, we

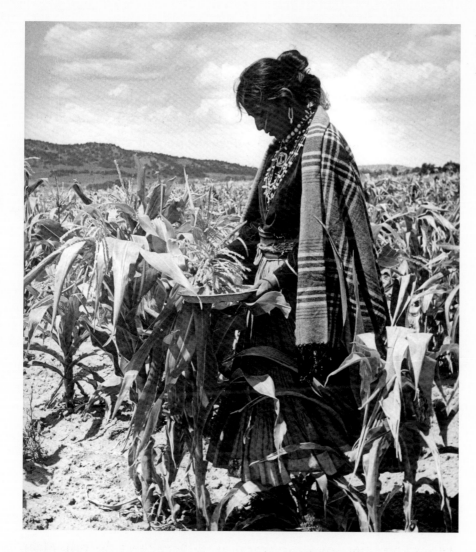

are the 'younger brothers' of the other creatures and therefore have to learn everything from them. Our real interest should not be to discover the abstract structure of physical reality, but rather to find the proper road down which to walk."

This "proper road" is the manner in which Native people should conduct their lives, in balance and harmony, respectfully celebrating the gift of plants that the Creator has given us.

— SHIRLEY CLOUD-LANE

A Resounding Voice

As an aspiring chef in the mid-1990s, I looked around one day and realized that there was almost no authentic representation of Native Americans in the world of professional cooking. There was also a startling lack of appreciation for the immense depth and rich legacy of indigenous cuisine. Based on this simple observation, I embarked on a journey that has fundamentally changed my life. It is a journey the roots of which can be traced to my days growing up on the White Mountain Apache and Diné (Navajo) reservations, looking for a path in life. The path I found, as a professional chef, has led me beyond mere youthful curiosity toward a deeper understanding of my culture and my calling. On this journey, I found a hidden voice that speaks to me in the universal language of taste. Over time, I came to understand that it was a voice that needed to be shared.

In 2003, as a way of offering my growing expertise in ancient cooking techniques to the community and providing the world of emerging Native chefs with an active network, I founded the first culinary organization for Native peoples. Through the Native American Culinary Association (NACA), up-and-coming culinary students and trained chefs from all corners of Indian Country have come together in a national forum. At last, we have a vehicle for the research, development, and preservation of traditional foods from the first peoples of the Americas.

Few Americans today have heard of the Mandan peoples from the upper Missouri River country, who were masters of the floodplains they occupied, conquering hunger through their agrarian prowess. Nor are they aware of the planting techniques of the Diné, which were so impressive that the first Spanish chroniclers spoke of the Diné as "the people with the great planted fields." For Native peoples across the Americas, methods of growing crops and reliably storing food and seeds were highly specialized and central to the fabric of tribal life. These lifeways were abruptly disturbed in the violent clash of cultures that followed the

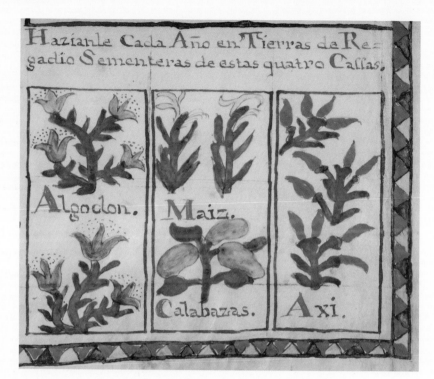

Haziante Cada Año en Tierras de Regadio Sementeras de estas quatro Callas.

Algodon.

Maiz.

Calabazas.

Axi.

Detail of painted tribute record representing goods given in trade: cotton, corn, squash, and hot peppers, 18th c. copy of ca. 16th c. original, Puebla, Mexico. 8/4482

arrival of Europeans in North America. It was a confrontation that has lasted over 500 years and imposed on Indians the reservation system and a new diet of cheap, high-fat, and high-carbohydrate commodity foods. "The commodz," as they are popularly known, consist of sugar, lard, refined flour, and processed meats distributed by the U.S. government. The consumption of these foods has produced diabetes, heart disease, and obesity — killer diseases that run rampant in Native communities. This relentless physical decline is a result of what I call the Great Interruption in the evolution of Native culture and cuisine.

My vision as a chef is to recapture the vast culinary and cultural heritage of our ancestors, returning to the traditional foods that once sustained us and reversing the decades of physical and cultural erosion. By working with the simple, hand-processed foods of past generations (which some chefs have ignorantly dismissed as "primitive"), we can educate the broader public not only about their benefits but also about

the sophisticated agricultural achievements of Native America. Through NACA, we are attempting to re-introduce American Indian flavors and philosophies to the world palate and dramatically improve public health in Native communities.

The deeper I delved into the culinary history of indigenous peoples of the Americas, the more I realized that food is a central means of retelling history, retaining culture, and creating a pathway for future generations. In my lectures and demonstrations to young culinary arts students in Native communities, I often present dishes such as Western Apache acorn stew and racket bread or Navajo steamed corn stew and fry bread — traditional dishes that are pure reflections of my own cultures. I encourage students to think outside the boundaries of classic European cuisine and find inspiration from their home communities and traditions. For example, we discuss how indigenous food staples such as tepary beans, cholla buds, acorn flour, Apache salt, wild rice, blue and white corn flour, and Indian tea can be the centerpieces of modern, upscale dishes. Traditional, seasonal foods can be combined in innovative ways that are considered serious cuisine.

In addition to the use of these fortifying and healthy staples, I feel that chefs must also give voice to the rich traditions of history and even spirituality in the preparation of indigenous foods. My father, Vincent Craig, introduced me to this concept. He encouraged me to incorporate Diné teachings into my work and taught me how to translate those teachings into English. When I began to use the actual philosophies of the Diné and my mother's Apache people in the conceptual, planning, production, and evaluation stages of my culinary operations, I found that the age-old teachings were effective and comprehensive. My father taught me how to approach modern cooking using a traditional "problem solver" based on respect for the Four Directions. This problem solver helped me to organize effectively all aspects of culinary production. The number four is sacred to the Diné and Apache people, so the problem solver consists of four stages or directions.

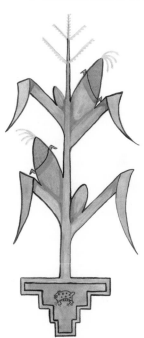

Lithographs made by John Garcia (Santa Clara Pueblo), 2003.

top left: *Ping piye (north), blue, and mountain lion.* D263046

top right: *Than piye (east), white, and badger.* D263043

bottom left: *Tsan piye (west), yellow, and black bear.* D263045

bottom right: *Akon piye (south), red, and bobcat.* D263044

East is the concept- or idea-development stage for planning a menu or particular dish. The food ingredient is still in its raw state. To the Diné people, the east is a sacred direction that represents a new day or new beginning, and traditionally, prayer is offered in this direction.

South represents a time for gathering and organizing ingredients, tools, and knives. In the classical French culinary tradition, this preparedness is known as *mise en place*, or "things in place."

West is the production or application stage, the point at which all ideas, tools, and resources are applied to cooking. This stage represents labor and production.

North corresponds to the evaluation stage, a time to try new strategies, ingredients, or cooking techniques in order to improve your work. The North also represents the conscious fulfillment of your blessings, when you reap the benefits of your successful ideas, thoughtful planning, and hard work.

These "Four Directives of Cuisine" can help to solve a simple or complex challenge when working with food — from envisioning how to work with familiar ingredients in a new way to creatively pairing various elements of a menu. As I adapted traditional philosophies to the creation of contemporary dishes, cooking soon changed from an occupation to a calling. I came to understand that cuisine is a direct representation of culture — food ties humans together and ensures survival. Now, as a chef, I know that "Native American cuisine" is born of survival and humility.

Both sides of my Diné and Apache family show great respect for food, its growth, and its preparation. We avoid waste and bless the food prior to eating. With such appreciation instilled in me, I offer a prayer before preparing food. Such reliance on the Creator ensures precision, diligence, and clarity of thought as I work to feed and nurture others. I also rely upon my family's tenacity and determination; both are required to endure the physical demands of service and long hours of labor in a profes-

sional kitchen. In addition, I am keenly aware that my ancestors survived by working together as a community; likewise, teamwork is also a vital element in my profession. It is from these inherited qualities that I draw inspiration.

My ancestors understood that proper rituals were responsible for ensuring balance and harmony within the community. Hard work and knowledge of the land — its sandy soils, short growing seasons, and uncertain amounts of water — were vital to the cultivation of crops and community survival, but paying proper respect was no less important. By conducting ceremonies to honor the sun and the gathering of seeds and observing the movements of the stars to determine when to plant, the people maintained the strength and stability of the community.

Food is history. Food is medicine. Food is even humility. Food relates to every aspect of human life — health, spirituality, ceremony, family, and culture. All human beings need to be fed and nurtured. Much was lost for Native peoples during the Great Interruption, particularly for the peoples who were relocated, but the traditions are powerful and still with us. Through my work with indigenous foods, seeds, and plants, I have found an intimate link among the physical, mental, and spiritual realms of Native people. Through NACA, I am striving to use this culinary and cultural heritage to build the future of Native American cuisine, to improve public health, and to help bring a spirit of renewal to the Native world.

— NEPHI CRAIG

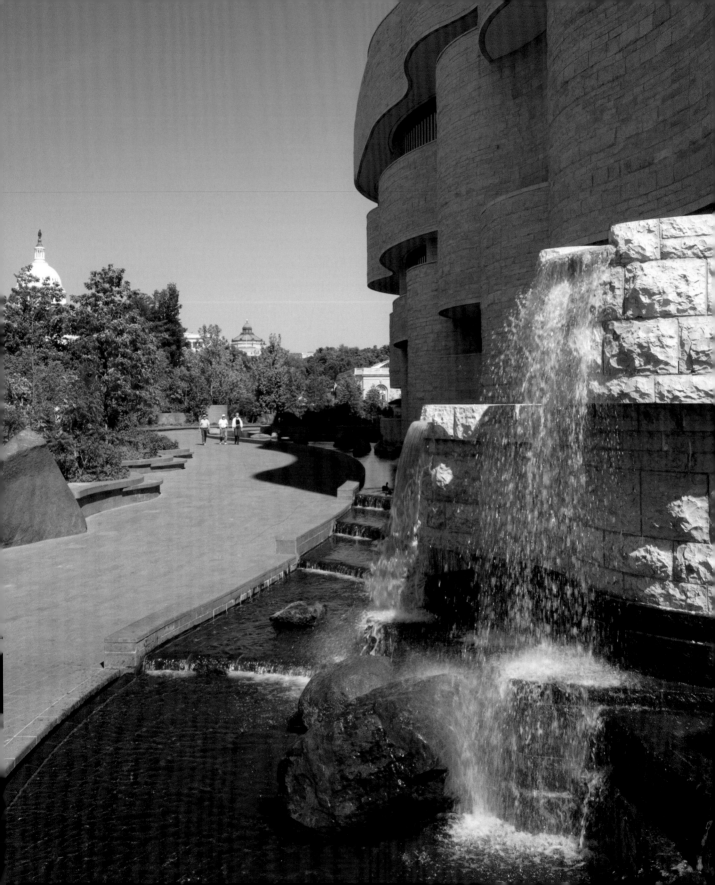

A SEASONAL GUIDE
TO THE LIVING LANDSCAPE

MARSHA LEA

Over a nine-year period beginning in 1993, I was fortunate enough to be a member of the design team responsible for creating a bold new environment on the National Mall — the landscape surrounding the National Museum of the American Indian. I recall a morning in early summer, prior to the museum's opening, when the plantings were not yet fully in place. Amid the cacophony of construction, a night heron visited the site, alighting on the fallen bald cypress tree in the wetlands area. The heron paused for several minutes before taking flight toward the nearby Anacostia River, leaving the crew hopeful that it would return again soon. For the design team and crew, this visit from the heron was an affirmation of what we had undertaken: the creation of a habitat surrounding the museum building that recalls the land's ecology prior to European contact and a celebration of our place in a fragile ecosystem. Developed in stages beginning in the summer of 2002, the landscape has literally taken on a life of its own; it has become not only a site for an interesting collection of plants that are native to the region but also a home to insects and animals.

I am often asked the best season for touring the NMAI landscape, to which I answer that every time of year offers its own particular gifts. This

View looking east along NMAI's north façade.

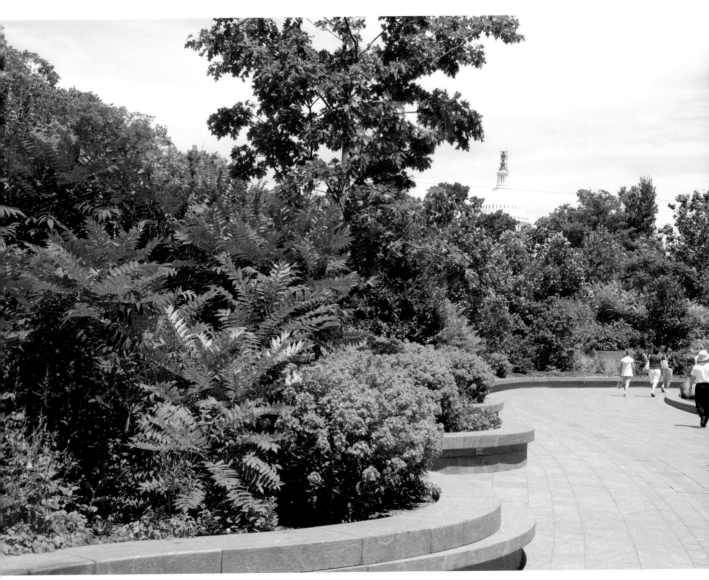

Bold lavender phlox, sumac, and oak trees in NMAI's woodlands.

Pawpaw tree.

essay is written as a kind of seasonal guide to the site. And in honor of the night heron that blessed our work, I begin with early summer.

A SUMMER VISIT

Summer in Washington, D.C., is steamy and almost semitropical, the woodlands understory thick with ground covers, vines, and shrubs. Approaching the museum from the northwest corner, walking along the path adjacent to the water feature, provides a cool respite from the intense heat. With the "river" on your right and the ironwood, ash, sassafras, and pawpaw of the woodlands forest on your left, immersion in the museum's environment is nearly total.

Facing the U.S. Capitol at the museum's Welcome Plaza, the wetlands area presents itself, filtered from view by the spicebush, summersweet, hazel alder, silky dogwood, and other wetlands woody shrubs. The dis-

Facing Challenges and Maintaining Balance

The federal city envisioned by Pierre L'Enfant and others who followed was set in a monumental, monolithic, and monochromatic landscape, a formal and ceremonial backdrop for the most important federal buildings in the United States. The landscape of the National Mall itself makes physical reference to our political system in its recognition of the three branches of government through their locations within the monumental core of Washington, D.C., and the physical form of streets, avenues, and the open spaces and landscape that surround them. In contrast, the site on which the National Museum of the American Indian (NMAI) is built was designed to reflect a return to the natural world, offering a respite from the otherwise groomed and sculpted National Mall.

The plants used to create the NMAI habitat are native to the Mid-Atlantic Piedmont. The original vision for the museum landscape included the creation of a diverse range of habitats, from arid upland forest to wetlands, and during the design process, we worked to carefully balance walkways and other functional areas surrounding the museum with habitats of flora and fauna. Soils were created to replicate the pH levels, organic content, and composition necessary to support the various plant communities envisioned for these habitats.

A primary goal for the museum habitat was to create a landscape of native materials without the inclusion of introduced cultivars — cultivated plants named for their desirable characteristics (decorative or useful) and thereby distinguished from similar plants of the same species. This requirement proved to be more difficult than anticipated as the schedule for landscape planting changed over the course of construction. Thousands of herbaceous perennials were planted at NMAI over the course of several months, with shipments of plants arriving daily for several weeks. Donna House (Diné/Oneida) and Mike Arnold, a landscape architect from EDAW, stood watch over the plant deliveries, checking the plants and rejecting those that were discovered to be cultivars. Both were ada-

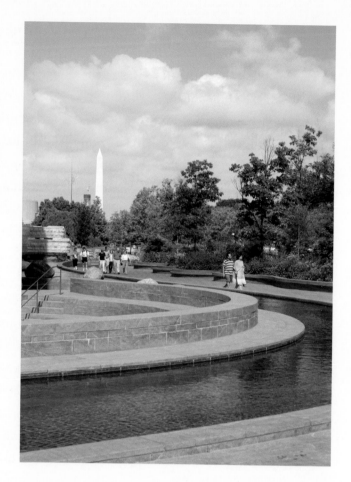

Visitors enjoy the museum's early summer landscape.

mant that the vision of planting only straight plant species be maintained. Still, many plants arrived in a dormant state, buried in the soil, making identification impossible. Other plants appeared to be the straight species until they bloomed in colors found only in cultivars. Despite the challenges faced during construction, with a few exceptions, the plantings are as intended, showcasing native flora of cultural significance.

Despite careful planning and planting, a range of uncontrollable factors came into play as well, including the arrival of seeds from adjacent landscapes. Until the groundcover planting is fully developed, invasive exotics and even invasive natives will threaten the balance and purity of the plantings at NMAI. Ailanthus is a particularly aggressive exotic tree

that has found a foothold in Washington, D.C. With a leaf similar to sumac, at first glance it seems to belong in the landscape, but it does not, and its prolific seed production requires immediate removal and constant vigilance to keep it in check.

Another particular challenge was the establishment of a healthy wetlands community. Wetlands plants rely on various water depths for their sustainability, and given that the museum landscape is approximately four acres and the wetlands only one-third of an acre, providing the gentle slopes, sufficient water-surface area, and various water depths necessary was difficult. Wetlands are also not typically subject to the high levels of airborne particles that occur in urban areas, which add silt and heavy metals to the soil. The natural cycle of growth, death, and decay of wetlands plants presents other challenges, as it adds to the organic matter in the bottom of the wetlands and may eventually fill it in. In addition, two plants of cultural significance, the water lily and the cattail, are aggressive growers that have thrived at the site. They have been harvested several times in an effort to check their dominance and maintain open water.

Adding to the complexities, the wetlands area attracted mallard ducks, a migratory species protected by U.S. Fish and Wildlife Service regulations, even before it was fully formed and filled with water. Mallards like the water features found throughout the monumental core of Washington, D.C., but they seem to find the wetlands and the fountain at NMAI particularly enticing. The first pair of ducks arrived in the spring, about the same time that the first wetlands plants arrived at the site. Without waiting for the plants to be installed, a female mallard nested in a box of bulrush plants. The duck population quickly expanded to twenty-nine adult mallards and ducklings, and whole beds of wild rice plants were lost to their voracious appetites. While the ducks' continued interest in the site affirms the success of the habitat creation, the museum grounds have suffered. The water's edge is trampled, in turn killing some of the edge plants and leaving the earth compacted and bare in places. Water quality has also suffered with the addition of organic matter. Unfortunately, man-

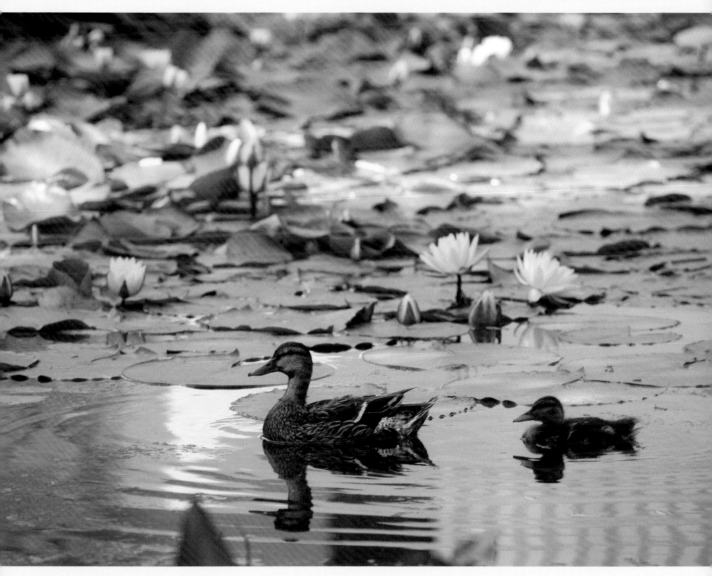

Mallard ducks among the water lilies.

Painted and feathered duck decoy and plain duck decoy, Humboldt County, Nevada, ca. A.D. 200. 13/4512D, 13/4513

aging the duck population continues to be a constant challenge for the museum. To respond to the situation, staff from the horticulture, facilities, and visitor services units are working together to closely monitor the duck families that reside on site, protecting them from curious visitors while maintaining the health of the wetlands environment.

Creating an upland forest presented another unique set of problems for the design team. Establishing a community of plants that thrives in the shaded understory of mature woodlands is difficult. While trees of some girth were planted at the outset, they do not provide the forest canopy needed to nurture mayapples, bloodroot, trout lily, and other shade-loving flora. Marked with insect damage, many of the mayapples are

Bloodroot.

yellowish-green in color rather than a rich glossy green. Naturally occurring symbiotic relationships between plants and other creatures are also difficult to create and are missing in places throughout the habitat. Ants are necessary for bloodroot to spread successfully, and certain microorganisms need to be present in the soil for winterberry to grow healthy and colonize. Eventually, if some species do not thrive, more adaptable plants such as coral bells, wild strawberry, and violet will overwhelm the less strident. The NMAI grounds will lose the diversity and interest that was intended for the flora and, in so doing, will lose the diversity of fauna and insect life.

The plantings surrounding the National Museum of the American Indian are not so much a landscape for an important building as a habitat that celebrates nature. Thanks to the establishment of proper conditions and initial plantings of indigenous species, the site has evolved, becoming a home to more than just plants and a building: it offers a welcome respite for those who come to learn about and celebrate Native American culture.

— MARSHA LEA

Water lilies, sweetbay magnolia tree, and pickerelweed in NMAI'*s wetlands.*

tinctive fruit of the buttonbush hangs over the edge of the seatwall, blueberries are full-blown but not yet ripe, and iridescent dragonflies skim across the water. By midsummer, water lilies will open in the light of late morning and close as the sun travels across the sky, reflected in the open water of the pond. The building's mirror image shimmers along with them. Purple blooms of pickerelweed edge the wetlands pond, along with sedge and bulrush.

This is the time to witness summer phlox in bold lavender bloom in the eastern portion of the site. The phlox and bright red cardinal flower stand in stark contrast to the creamy white blooms of the wild hydrangea, soft and quiet below the canopy of tulip poplars, sycamores, and green ash. On the sunny south side of the museum, corn, beans, and squash are interplanted in the traditional way, a relationship of mutual support that Native people recognized long ago. Nearby, broad hairy tobacco leaves await collection and drying, while sunflower heads track the course of the sun.

A large pair of American elms, protected during the museum's construction, stand sentinel near the southern entrance, offering shade to the visiting public as well as their companions in the landscape. Caring for the elms involved surrounding them with protective fencing, fertilization, supplemental watering, and monthly monitoring to assess construction impact. The team eventually added a stake and a plumb line to track any movement of the leaning trunk of one of the trees; no additional leaning occurred. American elms are native to the eastern United States, flourishing in the moist forests and river bottoms of the region. Their broad, arching form; rapid growth rate; and tolerance of a range of growing conditions make them a popular street tree in many American cities. Washington, D.C., is no exception; its rows of elms define the National Mall and create a majestic setting for its monuments and federal buildings. Interestingly, these trees planted so formally along the Mall were most likely growing in and around the site in the pre-colonial landscape of the Potomac River valley.

Completing a summer tour of the museum, a visitor will find sumac, juniper, goldenrod, coneflower, and black-eyed Susan along the western side of the building. While this is a relatively thin sliver of land, the space presents one of the museum grounds' ideal compositions. With its exuberant foliage and blooms, it is a perfect counterpoint to the formal layout of the street trees and lawn along the Fourth Street curb, and the plantings soften the western canyonlike wall of the museum.

AN AUTUMN SOJOURN

Come autumn, the sumac turns bright red-orange, and the little bluestem turns golden in color. Placement of these varieties recalls the approach used by the noted early twentieth-century landscape architect Jens Jensen, a strong proponent of native plantings who positioned plants with red foliage so that the setting sun would bathe them in late afternoon

left: *Sumac leaves in autumn.*

right: *Southern magnolia.*

light. The museum's fiery sumac treats visitors to a dramatic display of color during this time of year.

Early autumn also unveils the deep red of the tupelo, reflected in the wetlands pond and bright against the feathery foliage of the bald cypress trees. In contrast to the green flora of trees that have yet to start turning color, the tupelo's vibrant hue hints at the cool weather and wondrous fall show that are soon to follow.

As autumn deepens, the viburnum turns yellow-burgundy, with ripe berries that attract a host of birds. Tulip poplars glow yellow in the sun, outshining the more subtle yellows of the hickories, fringetrees, and sweetbay magnolias. The museum woodlands habitat is too young yet to produce pawpaw fruit or pignuts, but once it does, the habitat will be attractive to more species of fauna, such as squirrels, insects, and a variety of birds.

Always Becoming *sculptures under an American elm in* NMAI's *meadow.*

Indigenous Geography/
Geografía Indígena

The Community and Constituent Services Department of the National Museum of the American Indian manages a bilingual website that emphasizes the importance of place. Indigenous Geography/Geografía Indígena invites communities to discuss who they are and where they live. Each community authors a series of essays centering on several themes: living world, economy, family, ritual, origins, community, seasons, and place. The first-person narratives combine with rich photography, short videos, and audio clips to provide an intimate and detailed sense of place and an idea of the rich bounty of the earth that surrounds the community.

The Indigenous Geography/Geografía Indígena website is one of many community-based, international resources exploring the relationship between Native peoples and the environment. Appendix 1 offers selected books, websites, and organizational contacts for further study.

— AMY VAN ALLEN

Guatemala countryside featured on Q'eqchi Maya community profile, 2005.

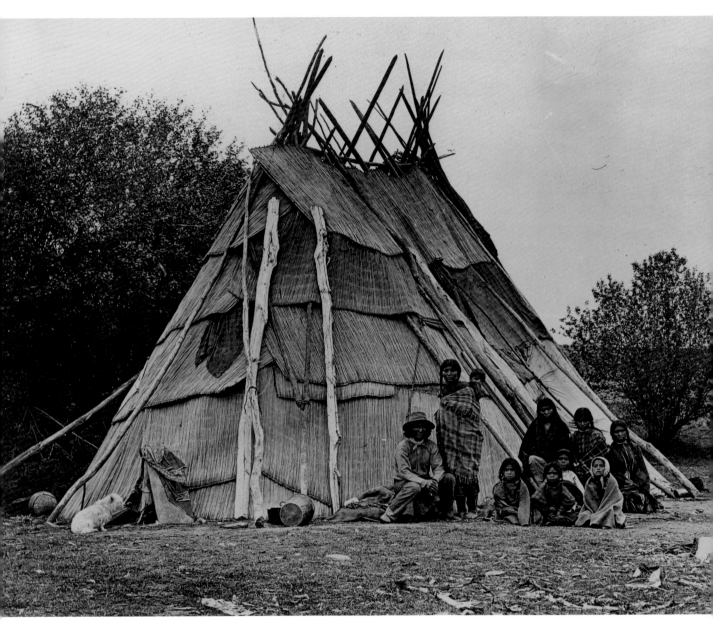

Umatilla group in front of dwelling covered with reed mats,
Umatilla Reservation, Oregon. P09313

A WINTER WALK

Winter exposes the structure of the plants and the profile of the land. River birch trees frame the western entrance to the site, sharing welcoming duties with falling water and the Grandfather Rocks. Their peeling orange bark calls to mind the cultural significance of the plants used to create NMAI's habitat. Native communities have traditionally used indigenous plants to make their clothes, homes, medicines, and weapons. Cedar, tobacco, and other plants are important in their ceremonies. A walk outside the museum walls introduces visitors to a wealth of raw materials central to many of the beautiful objects they will find within.

Winter transforms the bald cypress trees into strong pyramidal silhouettes. Winterberries remain red long after their leaves have fallen, and the green of the American holly trees deepens, lending a perfect background for their own crimson berries. In addition to offering dramatic beauty, the cold season provides the museum habitat with an opportunity to rest and replenish itself. Fallen leaves and decaying branches add organic matter to the soil, affecting soil texture and pH levels. Seeds drop and sprout as seedlings in the spring. Each season of growth brings a change in the balance and composition of the habitat.

A SPRING STROLL

Spring celebrates rebirth and renewal with a profusion of ephemerals, or wildflowers, in the upland forest. Before the leaves unfurl on trees and shrubs, the bloodroot, hepatica, shootingstar, and springbeauty bloom. The understated, alluring spring landscape rewards those who observe it closely. The bolder mayapple unfolds its umbrella of foliage, and Jack-in-the-pulpit shoots upward. Near the wetlands, trout lily is planted in broad sweeps, its speckled foliage named for the fish. Nearer still to the water's edge, yellow marsh marigold and sweet flag bloom. This fertile season brings with it the fragrance of sweetbay magnolia and warm soil.

Moss phlox.

Christmas fern.

left: *Jack-in-the-pulpit.*

right: *Columbine.*

The habitat at NMAI is not simply a seasonal landscape — it is one that changes hourly. Visitors experience a different landscape in the mid-morning than in the afternoon, and many find that their favorite time to visit is based not on the season but on the hour of day. A time of special magic is the early morning, before the Mall and its environs fully awaken and begin to hum with activity.

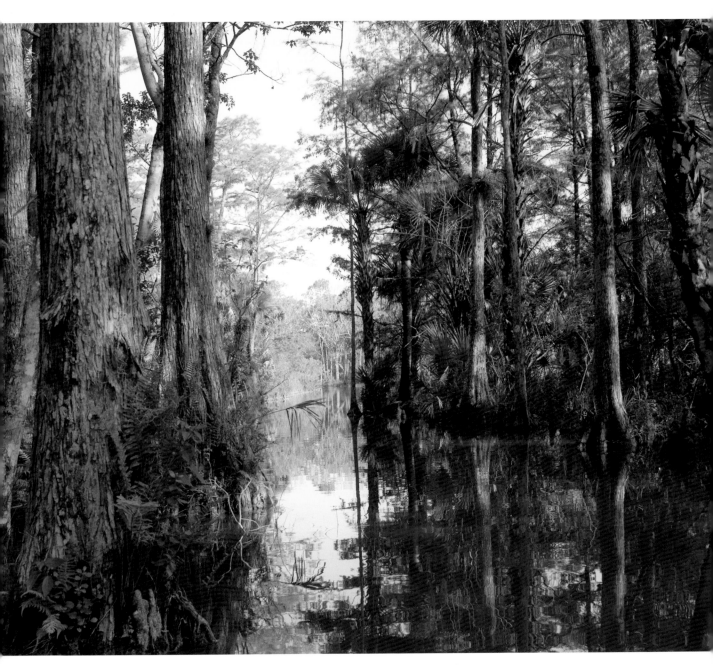

Cypress trees on the Seminole reservation, Florida, 2003.

Selected Resources & Organizations

Akwesasne Task Force on the Environment
P.O. Box 992
Hogansburg, New York 13655
Phone: 518-358-9607
Website: www.northnet.org/atfe/atfe.htm

Alaska Native Knowledge Network
University of Alaska Fairbanks
P.O. Box 756730
Fairbanks, Alaska 99775-6730
Phone: 907-474-1902
Website: www.ankn.uaf.edu

American Indian Ethnobotany Database
University of Michigan–Dearborn
2134 CASL Annex
4901 Evergreen Road
Dearborn, Michigan 48198
Website: http://herb.umd.umich.edu

Center for Indigenous Knowledge for
 Agriculture and Rural Development
Iowa State University
318 Curtiss Hall
Ames, Iowa 50011
Phone: 515-294-0938
Website: www.ciesin.org

Center for Native Peoples and the
 Environment
State University of New York College of
 Environmental Science and Forestry
1 Forestry Drive
Syracuse, New York 13210
Phone: 315-470-6785
Website: www.esf.edu/nativepeoples

Center for Sustainable Environments
Northern Arizona University
P.O. Box 5765
Flagstaff, Arizona 86011-5765
Phone: 928-523-6726
Website: http://home.nau.edu/
 environment

Centre for Indigenous Environmental
 Resources
245 McDermot Avenue
Winnipeg, Manitoba
CANADA R3B 0S6
Phone: 204-956-0660
Website: www.cier.ca

Eastern Native Seed Conservancy
P.O. Box 451
Great Barrington, Massachusetts 01230
Phone: 413-229-8316
Website: www.enscseeds.org

Haskell Environmental Research
 Studies Center
Haskell Indian Nations University
155 Indian Avenue
Lawrence, Kansas 66046
Phone: 785-832-6677
Website: www.haskell.edu

Haudenosaunee Native Seed Collective
166 Chestnut Hill Road
Orange, Massachusetts 01364
Phone: 978-790-8875
Website: www.growseed.org/NA

Honor the Earth
2104 Stevens Avenue South
Minneapolis, Minnesota 55404
Phone: 612-879-7529
Website: http://honorearth.com

Indigenous Environmental Network
Bemidji Main Office
P.O. Box 485
Bemidji, Minnesota 56619
Phone: 218-751-4967
Website: www.ienearth.org

Indigenous Geography/Geografía Indígena
National Museum of the American Indian
Websites: www.indigenousgeography.
 si.edu, www.geografiaindigena.si.edu

Native American Culinary Association
16356 North Thompson Peak Parkway,
 #1046 N
Scottsdale, Arizona 85255
Website: www.nativeculinary.com

Native Seeds/SEARCH
526 North 4th Avenue
Tucson, Arizona 85705-8450
Website: www.nativeseeds.org

Traditional Native American Farmers
 Association
P.O. Box 31267
Santa Fe, New Mexico 87594-1267
Website: www.7genfund.org/aff-tra-
 nat-ame.html

White Earth Land Recovery Project and
 Native Harvest Online Catalog
607 Main Avenue
Callaway, Minnesota 56521
Phone: 800-973-9870
Website: www.nativeharvest.com

NMAI Plant List

TREES

Botanical Name	Common Name	Family Name	Landscape Habitat
Acer rubrum	Red maple	Aceraceae	Wetlands
Amelanchier arborea	Downy serviceberry	Rosaceae	Wetlands
Asimina triloba	Common pawpaw	Annonaceae	Woodlands
Betula nigra	River birch	Betulaceae	Wetlands
Carpinus caroliniana	American hornbeam	Betulaceae	Woodlands
Carya glabra	Pignut hickory	Juglandaceae	Woodlands
Castanea pumila	Chinkapin	Fagaceae	Woodlands
Chionanthus virginicus	White fringetree	Oleaceae	Woodlands
Cornus florida	Flowering dogwood	Cornaceae	Woodlands
Fraxinus pennsylvanica	Green ash	Oleaceae	Woodlands
Ilex opaca	American holly	Aquifoliaceae	Wetlands
Juglans nigra	Black walnut	Juglandaceae	Wetlands
Juniperus virginiana	Eastern redcedar	Cupressaceae	Woodlands
Liriodendron tulipifera	Tuliptree	Magnoliaceae	Woodlands
Magnolia grandiflora	Southern magnolia	Magnoliaceae	Woodlands
Magnolia virginiana	Sweetbay	Magnoliaceae	Wetlands
Nyssa aquatica	Water tupelo	Cornaceae	Wetlands
Nyssa sylvatica	Blackgum	Cornaceae	Woodlands
Pinus virginiana	Virginia pine	Pinaceae	Woodlands
Platanus occidentalis	American sycamore	Platanaceae	Woodlands
Quercus alba	White oak	Fagaceae	Woodlands
Quercus coccinea	Scarlet oak	Fagaceae	Woodlands
Quercus phellos	Willow oak	Fagaceae	Woodlands
Quercus rubra	Northern red oak	Fagaceae	Woodlands
Sassafras albidum	Sassafras	Lauraceae	Woodlands
Taxodium distichum	Bald cypress	Cupressaceae	Wetlands
Ulmus americana 'New Harmony'	'New Harmony' American elm	Ulmaceae	Perimeter planters

SHRUBS

Botanical Name	Common Name	Family Name	Landscape Habitat
Alnus serrulata	Hazel alder	Betulaceae	Woodlands
Cephalanthus occidentalis	Common buttonbush	Rubiaceae	Wetlands
Clethra alnifolia	Coastal sweetpepperbush	Clethraceae	Woodlands
Cornus amomum	Silky dogwood	Cornaceae	Wetlands
Corylus americana	American hazelnut	Betulaceae	Woodlands
Euonymus americanus	Strawberry bush	Celastraceae	Woodlands
Hamamelis virginiana	American witchhazel	Hamamelidaceae	Woodlands
Hydrangea arborescens	Wild hydrangea	Hydrangeaceae	Woodlands
Ilex verticillata	Winterberry	Aquifoliaceae	Woodlands
Itea virginica	Virginia sweetspire	Grossulariaceae	Woodlands
Kalmia latifolia	Mountain laurel	Ericaceae	Woodlands
Lindera benzoin	Northern spicebush	Lauraceae	Woodlands
Rhododendron periclymenoides	Pink azalea	Ericaceae	Woodlands
Rhododendron viscosum	Swamp azalea	Ericaceae	Woodlands
Rhus glabra	Smooth sumac	Anacardiaceae	Meadow
Rhus typhina	Staghorn sumac	Anacardiaceae	Woodlands
Rosa palustris	Swamp rose	Rosaceae	Wetlands
Salix sericea	Silky willow	Salicaceae	Wetlands
Vaccinium angustifolium	Lowbush blueberry	Ericaceae	Wetlands
Vaccinium corymbosum	Highbush blueberry	Ericaceae	Wetlands
Vaccinium macrocarpon	Cranberry	Ericaceae	Wetlands
Vaccinium stamineum	Deerberry	Ericaceae	Woodlands
Viburnum dentatum	Arrowwood viburnum	Caprifoliaceae	Woodlands
Viburnum prunifolium	Blackhaw viburnum	Caprifoliaceae	Woodlands

PERENNIALS

Botanical Name	Common Name	Family Name
Acalypha gracilens	Slender threeseed mercury	Euphorbiaceae
Acalypha virginica	Virginia threeseed mercury	Euphorbiaceae
Acorus calamus	Sweetflag	Acoraceae
Actaea racemosa	Black bugbane	Ranunculaceae
Allium canadense	Meadow garlic	Liliaceae
Allium cernuum	Nodding onion	Liliaceae
Andropogon gerardii	Big bluestem	Poaceae
Andropogon virginicus	Broomsedge bluestem	Poaceae
Anemone Americana	Roundlobe hepatica	Ranunculaceae
Aquilegia canadensis	Red columbine	Ranunculaceae
Arisaema triphyllum	Jack-in-the-pulpit	Araceae
Asarum canadense	Canadian wildginger	Aristolochiaceae
Asclepias incarnata	Swamp milkweed	Asclepiadaceae
Asclepias tuberosa	Butterfly milkweed	Asclepiadaceae
Calla palustris	Water arum	Araceae
Caltha palustris	Yellow marsh marigold	Ranunculaceae
Camassia scilloides	Atlantic camas	Liliaceae
Campsis radicans	Trumpet creeper	Bignoniaceae
Carex amphibola	Eastern narrowleaf sedge	Cyperaceae
Chrysopsis mariana	Maryland goldenaster	Asteraceae
Claytonia virginica	Virginia springbeauty	Portulacaceae
Desmodium nudiflorum	Nakedflower ticktrefoil	Fabaceae
Dicentra cucullaria	Dutchman's breeches	Fumariaceae
Dodecatheon meadia	Shootingstar	Primulaceae
Echinacea purpurea	Eastern purple coneflower	Asteraceae
Equisetum arvense	Field horsetail	Equisetaceae
Erigeron annuus	Eastern daisy fleabane	Asteraceae
Erigeron strigosus	Prairie fleabane	Asteraceae
Erythronium americanum	Dogtooth violet	Liliaceae
Eupatorium maculatum	Spotted Joe-pyeweed	Asteraceae
Eurybia divaricata	White wood aster	Asteraceae
Fragaria virginica	Virginia strawberry	Rosaceae
Gaultheria procumbens	Eastern teaberry	Ericaceae
Glyceria striata	Fowl mannagrass	Poaceae

PERENNIALS *(continued)*

Botanical Name	Common Name	Family Name
Helianthemum canadense	Longbranch frostweed	Cistaceae
Heuchera americana	American alumroot	Saxifragaceae
Hibiscus moscheutos	Crimsoneyed rosemallow	Malvaceae
Juncus tenuis	Path rush	Juncaceae
Liatris pilosa	Shaggy blazing star	Asteraceae
Lobelia cardinalis	Cardinalflower	Campanulaceae
Lobelia siphilitica	Blue lobelia	Campanulaceae
Mentha arvensis	Wild mint	Lamiaceae
Mertensia virginica	Virginia bluebell	Boraginaceae
Monarda fistulosa	Beebalm	Lamiaceae
Nuphar lutea	Yellow pond-lily	Nymphaeaceae
Nymphaea oderata	American white water lily	Nymphaeaceae
Orontium aquaticum	Golden-club	Araceae
Panax quinquefolius	American ginseng	Araliaceae
Panicum virgatum	Panic grass	Poaceae
Panicum clandestinum	Deertongue	Poaceae
Panicum depauperatum	Starved panic grass	Poaceae
Panicum dichotomiflorum	Fall panic grass	Poaceae
Parthenocissus quinquefolia	Virginia creeper	Vitaceae
Penstemon digitalis	Talus slope penstemon	Plantaginaceae
Penstemon laevigatus	Eastern smooth beardtongue	Scrophulariaceae
Phemeranthus teretifolius	Quill fameflower	Portulacaceae
Phlox paniculata	Fall phlox	Polemoniaceae
Phlox subulata	Moss phlox	Polemoniaceae
Podophyllum peltatum	Mayapple	Berberidaceae
Polypodium virginianum	American wall fern	Polypodiaceae
Polystichum acrostichoides	Christmas fern	Dryopteridacea
Pontederia cordata	Pickerelweed	Pontederiaceae
Pteridium aquilinum	Western brackenfern	Dennstaedtiaceae
Ranunculus abortivus	Buttercup	Ranunculaceae
Ranunculus ficaria	Lesser celandine	Ranunculaceae
Rudbeckia hirta	Black-eyed Susan	Asteraceae
Rudbeckia triloba	Three-lobed coneflower	Asteraceae
Ruellia humilis	Fringeleaf wild petunia	Acanthaceae
Sagittaria latifolia	Arrowhead	Alismataceae

PERENNIALS *(continued)*

Botanical Name	Common Name	Family Name
Sanguinaria canadensis	Bloodroot	Papaveraceae
Saxifraga virginensis	Early saxifrage	Saxifragaceae
Schizachyrium scoparium	Little bluestem	Poaceae
Schoenoplectus tabernaemontani	Softstem bulrush	Cyperaceae
Scirpus cyperinus	Woolgrass	Cyperaceae
Scutellaria saxatillis	Skullcap	Lamiaceae
Silene virginica	Fire pink	Caryophyllaceae
Solidago bicolor	White goldenrod	Asteraceae
Solidago canadensis	Goldenrod	Asteraceae
Solidago juncea	Early goldenrod	Asteraceae
Solidago racemosa	Goldenrod	Asteraceae
Sorghastrum nutans	Indiangrass	Poaceae
Symphyotrichum cordifolium	Blue wood aster	Asteraceae
Symplocarpus foetidus	Skunk cabbage	Araceae
Thalictrum thalictroides	Rue anemone	Ranunculaceae
Typha latifolia	Broadleaf cattail	Typhaceae
Viola pennsylvanica	Smooth yellow violet	Violaceae
Viola primulifolia	Primrose-leaved violet	Violaceae
Viola striata	Striped violet	Violaceae
Zizania aquatica	Wild rice	Poaceae

CROPS

Botanical Name	Common Name	Family Name
Capsicum annuum	Hot pepper	Solanaceae
Cucurbita moshchata	Squash	Cucurbitaceae
Cucurbita pepo	Connecticut field pumpkin	Cucurbitaceae
Helianthus annuus	Sunflower	Asteraceae
Nicotiana tabacum	Tobacco	Solanaceae
Solanum lycopersicum	Tomato	Solanaceae
Zea mays	Corn	Poaceae

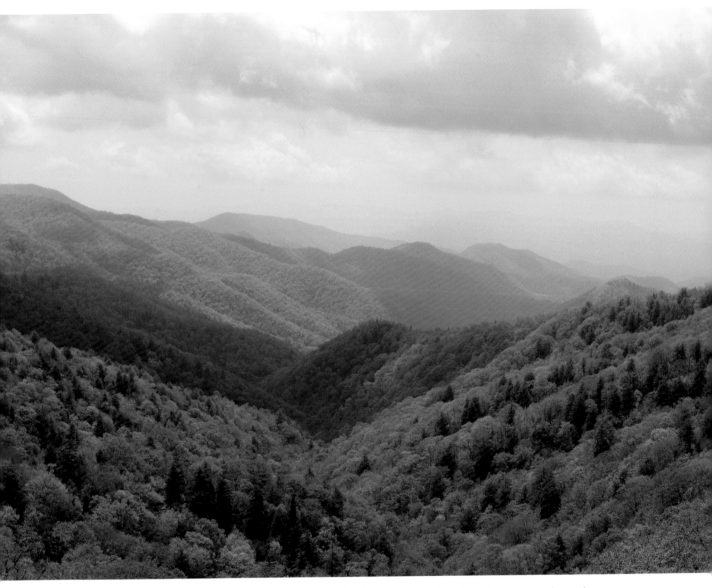

Qualla Boundary, homelands of the Eastern Band of Cherokee, North Carolina, 2003.

Selected Bibliography

Ash-Milby, Kathleen, ed. *Off the Map: Landscape in the Native Imagination*. Washington,
 D.C.: National Museum of the American Indian, Smithsonian Institution, 2007.

Benyus, Janine M. *Field Guide to Wildlife Habitats of the Eastern United States*. New York:
 Fireside, 1989.

Blue Spruce, Duane. *Spirit of a Native Place*. Washington, D.C.: National Geographic with
 the National Museum of the American Indian, 2005.

Cajete, Gregory, and Leroy Little Bear. *Native Science: Natural Laws of Interdependence*.
 Santa Fe: Clear Light Books, 1999.

Densmore, Frances. *How Indians Use Wild Plants for Food, Medicine, and Crafts*. New York:
 Dover Publications, 1974.

Divina, Fernando and Marlene. *Foods of the Americas: Native Recipes and Traditions*.
 Berkeley: Ten Speed Press, with the National Museum of the American Indian, 2004.

George, Chief Dan, and Helmut Hirnschall. *My Heart Soars*. New York: Hancock House,
 1974.

Godfrey, Michael. *Field Guide to the Piedmont*. Chapel Hill: University of North Carolina
 Press, 1997.

Hirschfelder, Arlene, ed. *Native Heritage: Personal Accounts by American Indians, 1790 to the
 Present*. New York: Macmillan, 1995.

Hutchens, Alma R. *A Handbook of Native American Herbs*. Boston: Shambhala, 1992.

Jensen, Derrick. "Where the Buffalo Go: How Science Ignores the Living World. An
 Interview with Vine Deloria, Jr." *The Sun*, July 2000, 4–13.

Kennedy, Frances H. *American Indian Places: A Historical Guidebook*. New York: Houghton
 Mifflin, 2008.

Kuhnlein, Harriet V., and Nancy J. Turner. *Traditional Plant Foods of Canadian Indigenous
 Peoples: Nutrition, Botany, and Use*. Philadelphia: Gordon and Breach, 1991.

Leopold, Donald J. *Native Plants of the Northeast: A Guide for Gardening and Conservation*.
 Portland, Ore.: Timber Press, 2005.

Lippard, Lucy R. *The Lure of the Local: Senses of Place in a Multicentered Society.* New York: New Press, 1997.

Marshall, Ann. *Rain: Native Expressions from the American Southwest.* Santa Fe: Museum of New Mexico Press, 2000.

Minnis, Paul E., and Wayne J. Elisens, eds. *Biodiversity and Native America.* Norman: University of Oklahoma Press, 2001.

Moerman, Daniel E. *Native American Ethnobotany.* Portland, Ore.: Timber Press, 1998.

Murphey, Edith Van Allen. *Indian Uses of Native Plants.* Glenwood, Ill.: Meyerbooks, 1987.

Nabakov, Peter. *Where the Lightning Strikes: The Lives of American Indian Sacred Places.* New York: Penguin Books, 2007.

Nabhan, Gary. *Enduring Seeds: Native American Agriculture and Wild Plant Conservation.* New York: North Point Press, 1991.

Peattie, Donald Culross. *A Natural History of Trees of Eastern and Central North America.* Boston: Houghton Mifflin, 1991.

Porterfield, Kay Marie, and Emory Dean Keoke, eds. *American Indian Contributions to the World: 15,000 Years of Inventions and Innovations.* New York: Checkmark Books, 2003.

Swentzell, Rina. "Mountain Form, Village Form: Unity in the Pueblo World." In *Ancient Land, Ancestral Places: Paul Logsdon in the Pueblo Southwest,* by Stephen H. Lekson and Rina Swentzell, 139–47. Santa Fe: Museum of New Mexico Press, 1993.

Tantaquidgeon, Gladys. *Folk Medicine of the Delaware and Related Algonkian Indians.* Harrisburg: Pennsylvania Historical and Museum Commission, 1972.

Yahner, Richard H. *Eastern Deciduous Forest: Ecology and Wildlife Conservation.* Minneapolis: University of Minnesota Press, 2000.

Contributors

KATHLEEN ASH-MILBY (Navajo) is an associate curator at NMAI's George Gustav Heye Center in New York. She is a researcher, writer, and curator of contemporary Native American art.

DUANE BLUE SPRUCE (Laguna/San Juan Pueblo), an architect, has been with NMAI since 1993 as facilities planning coordinator. He is currently at the George Gustav Heye Center in New York.

KRISTINE BRUMLEY, a former NMAI program assistant, now lives and works in Boise, Idaho.

SHIRLEY CLOUD-LANE (Navajo/Southern Ute) has served as an NMAI cultural interpreter since 2004. Her grandfather, a practicing Navajo herbalist, taught her to appreciate our relationship to plants and the earth.

ROGER COURTENAY, FASLA, an award-winning landscape architect, is a principal and vice president of EDAW, Inc., in Alexandria, Virginia, the world's largest landscape architecture, planning, and environmental consulting firm.

NEPHI CRAIG (Diné/White Mountain Apache), the founder of the Native American Culinary Association, is a practicing chef in Scottsdale, Arizona. He is currently developing a Native American culinary arts program.

RENÉE GOKEY (Eastern Shawnee/Sac and Fox) serves as NMAI student services coordinator. She has a B.A. in anthropology, with an emphasis in Native American studies, from the University of New Mexico.

KEVIN GOVER (Pawnee/Comanche) is the director of the National Museum of the American Indian. Prior to his appointment, he was a professor of law at the Sandra Day O'Connor College of Law at Arizona State University and co-executive director of the university's American Indian Policy Institute. A presidential appointee, Gover served

as the assistant secretary for Indian affairs in the U.S. Department of the Interior from 1997 to 2000.

JOHNPAUL JONES (Cherokee/Choctaw) is founding principal of Jones & Jones, Architects and Landscape Architects, based in Seattle, Washington. He is the recipient of many awards, including the 2006 American Institute of Architects Seattle Honors Medal.

MARSHA LEA is a landscape architect and principal with EDAW, Inc., in Alexandria, Virginia. Her recent projects include federal buildings, museums, university campuses, historic properties, and botanical gardens.

JOSÉ MONTAÑO (Aymara), an NMAI cultural interpreter, is a writer, educator, and musician. He was born in the small highland village of Incalacaya, Bolivia, and served as the director of Bolivia's premier folk music group, Grupo Aymara.

NORA NARANJO-MORSE (Santa Clara Pueblo) is an acclaimed sculptor, poet, author, and filmmaker from Espanola, New Mexico. She has participated in numerous exhibitions worldwide and received an honorary doctorate from Skidmore College in May 2007.

JAMES PEPPER HENRY (Kaw/Creek), former assistant director at NMAI, is currently the director and CEO of the Anchorage Museum at the Rasmusson Center in Alaska.

NANCY STRICKLAND (Lumbee), former NMAI teacher services coordinator, now works at the American Indian Cultural Center and Museum in Oklahoma City, Oklahoma.

GABRIELLE TAYAC (Piscataway) is a historian and researcher at NMAI, where she has written a book and served as curator for an exhibition on the history of the indigenous peoples of the Chesapeake Bay. She holds a doctoral degree from Harvard University.

TANYA THRASHER (Cherokee Nation of Oklahoma) has been with NMAI since 1998, where she is currently assistant head of publications. She received her M.A. in media and public affairs from The George Washington University in Washington, D.C.

AMY VAN ALLEN is the manager of professional outreach and international relations in NMAI's Constituent and Community Services unit.

Acknowledgments

The writing of *The Land Has Memory* has been a joyful collective effort. We owe a debt of gratitude to many friends, specifically to Donna House (Diné/Oneida), the notable ethnobotanist who originally envisioned the exterior plantings and worked with the landscape architecture firm EDAW of Alexandria, Virginia, to create four distinct environments that bring to life the plant and animal worlds of nearly 400 years ago. Today, visitors can learn about the indigenous plants of the Chesapeake Bay region, as well as how Native communities interacted with them, through an outdoor panel exhibition that highlights the building's design features, a variety of plant uses, and community stories. Tours of the landscape led by Native staff and programs featuring traditional planting, cooking, and cosmology complement the exhibition throughout the year.

The museum is grateful to all of the writers who shared their knowledge and passion for the environment with us for the benefit of this book. We particularly thank contributors Kathleen Ash-Milby (Navajo), Kristine Brumley, Roger Courtenay, Nephi Craig (Diné/White Mountain Apache), James Pepper Henry (Kaw/Creek), Johnpaul Jones (Cherokee/Choctaw), Marsha Lea, Nancy Strickland (Lumbee), Gabrielle Tayac (Piscataway), and Amy Van Allen for generously sharing their insights. We also appreciate the expertise of Christine Price-Abelow of the Smithsonian's Horticulture Services Division, whose intimate knowledge of the museum landscape greatly enhanced this book. Horticulture Services staff Paul Lindell, Tony Dove, and the late Dan Chiplis provided invaluable assistance in the project's development.

We owe thanks to Duane Blue Spruce (Laguna/San Juan Pueblo) and Tanya Thrasher (Cherokee Nation of Oklahoma), who served as dedicated co-editors and contributors for this volume. An original poem by Nora Naranjo-Morse (Santa Clara Pueblo), written on the occasion of her sculpture installation in the museum's landscape, reminds us of the earth's bounty.

This book would not have been produced without the commitment of the NMAI Publications Office, especially head of publications Terence Winch and managing editor Ann Kawasaki. NMAI editors Sally Barrows and Amy Pickworth and freelance editor Chris-

tine Gordon provided invaluable expertise in the research, copyediting, and proofreading stages. Photographers Ernest Amoroso, Katherine Fogden (Mohawk), Walter Larrimore, and Roger Whiteside of the museum's Office of Photo Services, headed by Cynthia Frankenburg, and NMAI program specialist Hayes Lavis took the beautiful color photographs of the landscape that bring the book's contents to life. Lou Stancari contributed photo research integral to the book's archival photographs.

For the outdoor exhibition, Associate Director for Museum Resources Tim Johnson, project manager Karen Fort, and exhibit manager Barbara Mogel ably guided a dedicated team, which included Shirley Cloud-Lane (Navajo/Southern Ute), Renée Gokey (Sac and Fox/Eastern Shawnee), José Montaño (Aymara), Gabrielle Tayac (Piscataway), and Tanya Thrasher (Cherokee Nation of Oklahoma). These staff members offered invaluable writing, research, and personal experiences that informed nearly every page of this book.

We would also like to extend our gratitude to Founding Director W. Richard West Jr. (Southern Cheyenne and member of the Cheyenne and Arapaho Tribes of Oklahoma), whose steadfast leadership throughout the planning, design, and construction of NMAI provided for a glorious building and landscape imbued with Native wisdom and understanding.

Throughout this volume, we come face-to-face with Mother Earth and some of her many offerings — male and female relationships, powerful medicine, sustenance, and the balance of all things. Through the interpretation of nature, even in our small ecosystems at the museum, we understand the importance and see the beauty of living life in harmony and preserving valuable resources for future generations. We hope this book and the landscape that inspired it bring some additional measure of beauty and wisdom to your life.

— KEVIN GOVER

Photo Credits

Images from the Photo Archives of the National Museum of the American Indian are identified in the captions by photograph or negative number; the photographers or collections, when known, are given below. Sources for other photographs are also identified below.

129, 130, © Hayes P. Lavis; 131, R. A. Whiteside; 133 left, Tim Laman/© National Geographic Stock; 133 right, © Hayes P. Lavis; 134–35, 136–37, Katherine Fogden; 140, 141, © Hayes P. Lavis; 142, 150, R. A. Whiteside.

The photographers for images of NMAI objects are given below.

xii, Ernest Amoroso; 12, Katherine Fodgen; 51, 72, 74, Ernest Amoroso; 75, courtesy Alan Michelson, photographs by Gwendolyn Cates, 2005; 76, 77, 78, 84, 90, Ernest Amoroso; 92, Walter Larrimore; 103 bottom, Ernest Amoroso; 115, Walter Larrimore; 117, 128, Ernest Amoroso.

Index

Note: Italic page numbers refer to illustrations.